THE DRAWING LESSON

THE DRAWING LESSON

A Graphic Novel That Teaches You How to Draw

Mark Crilley

WATSON-GUPTILL PUBLICATIONS
Berkeley

CONTENTS

Introduction 1

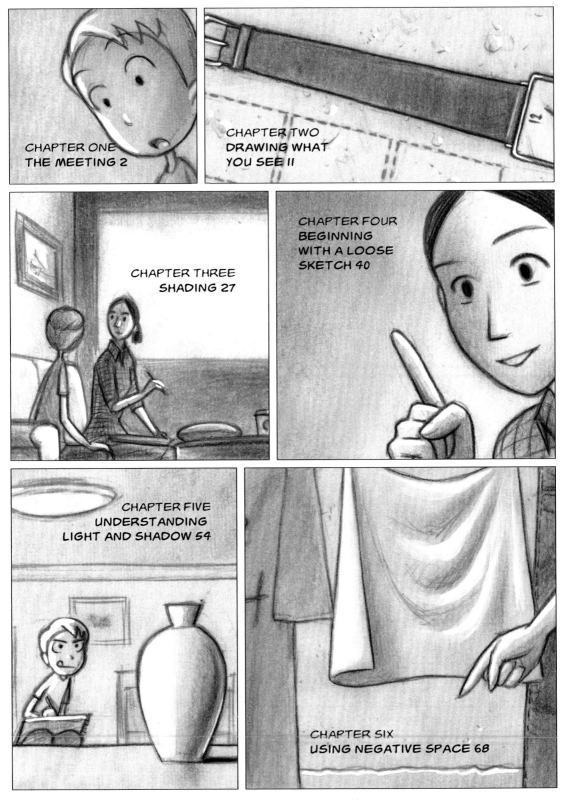

CHAPTER ONE
THE MEETING 2

CHAPTER TWO
DRAWING WHAT
YOU SEE 11

CHAPTER THREE
SHADING 27

CHAPTER FOUR
BEGINNING
WITH A LOOSE
SKETCH 40

CHAPTER FIVE
UNDERSTANDING
LIGHT AND SHADOW 54

CHAPTER SIX
USING NEGATIVE SPACE 68

CHAPTER SEVEN
CHECKING
PROPORTIONS 78

CHAPTER EIGHT
SIMPLIFYING THINGS 87

CHAPTER NINE
CREATING A
COMPOSITION 98

CHAPTER TEN
BRINGING IT ALL
TOGETHER 110

CHAPTER ELEVEN
MOVING ON 126

EPILOGUE 134

INTRODUCTION

Learning a trade very often involves seeking a mentor, and when it comes to learning how to draw, having a good mentor can make all the difference. There's no substitute for having a professional sitting right there next to you as you're trying to learn. Professional artists can see where your drawing is going astray. They can point out the discrepancies between the thing you're looking at and the picture you've drawn. They can get you to open your eyes and see things in a completely new way.

If all goes well, you may find such a mentor exactly when you need one, right there in the town where you live. But it doesn't always work out that way, does it? What if you're not so lucky? What if you go your whole life without finding even one person who can show you the ropes? It's a sad fact that many people never get the mentor they desperately need.

My goal with this book is to give you the next best thing: some sense of what it's like to meet a drawing expert and to have a series of lessons at his or her side. There's no shortage of instructional art books in the world; I've made a few of them myself. But I wanted to see if crucial lessons about drawing could be woven into an actual narrative. So, I set out to create a story that would give you vicariously the experience of having a mentor— one that can make you feel as if you are the one having your mistakes corrected, as if you are being told what to do and how to do it.

So, please turn the page, meet young David, and follow him on his drawing journey. I hope his story gives you some sense of what it's like to have a drawing mentor. Mentors are not always gentle, and they certainly aren't there just to be your personal cheerleader. But a mentor can truly change the way you see the world, and in so doing change your life altogether.

THE MEETING

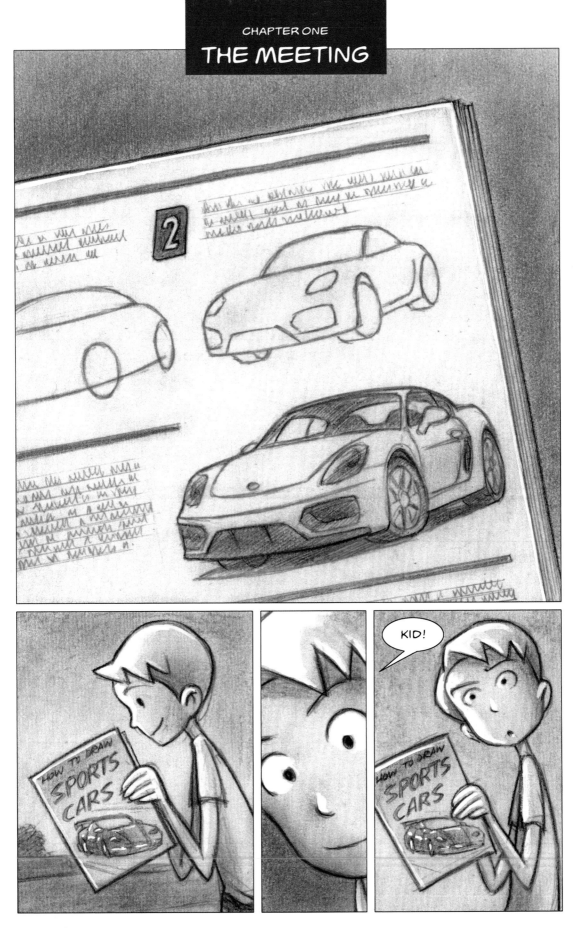

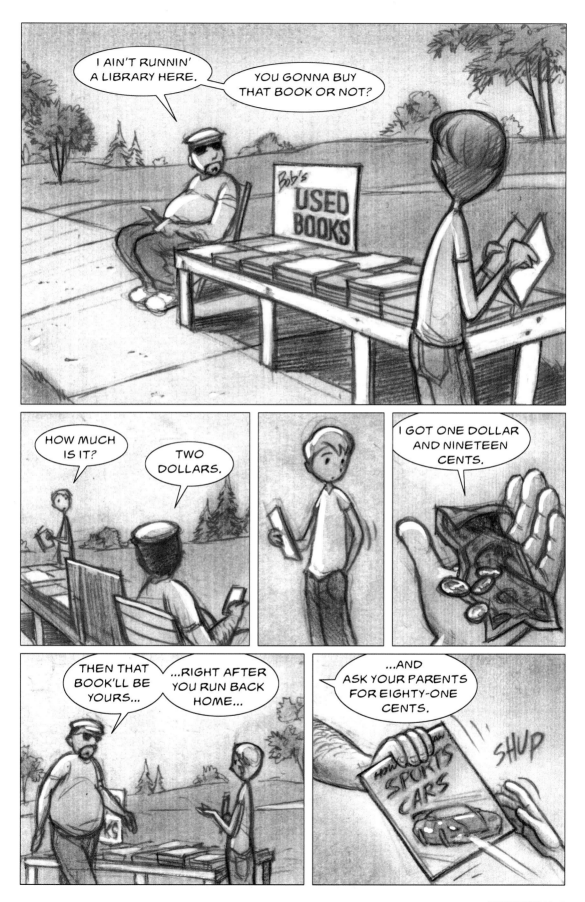

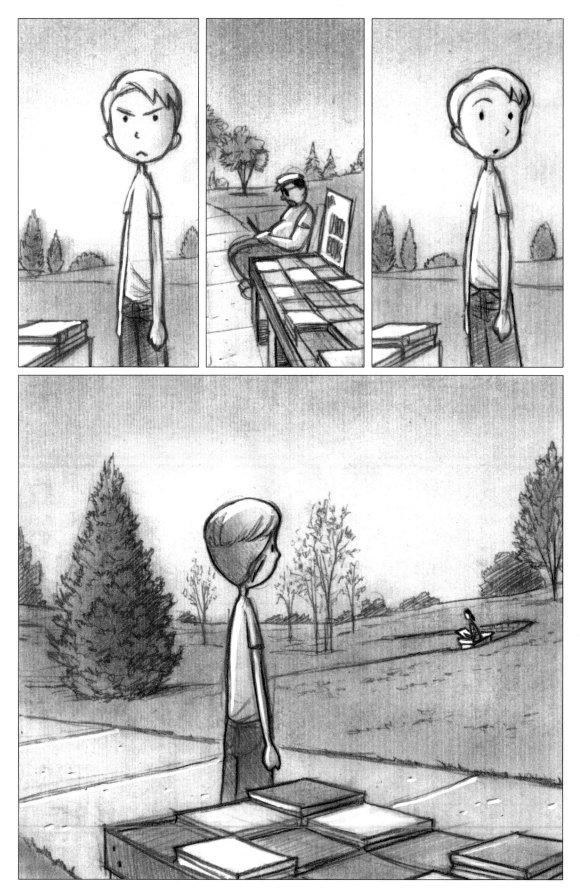

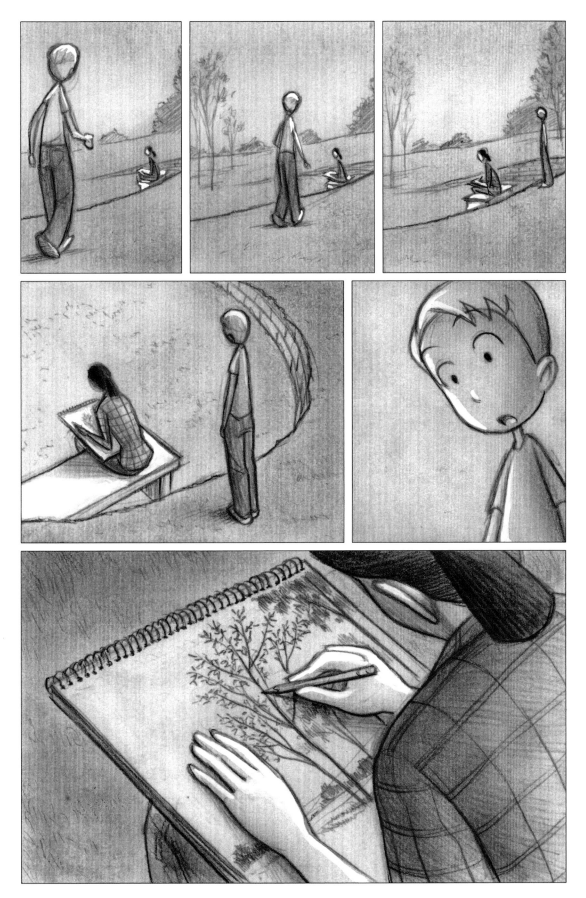

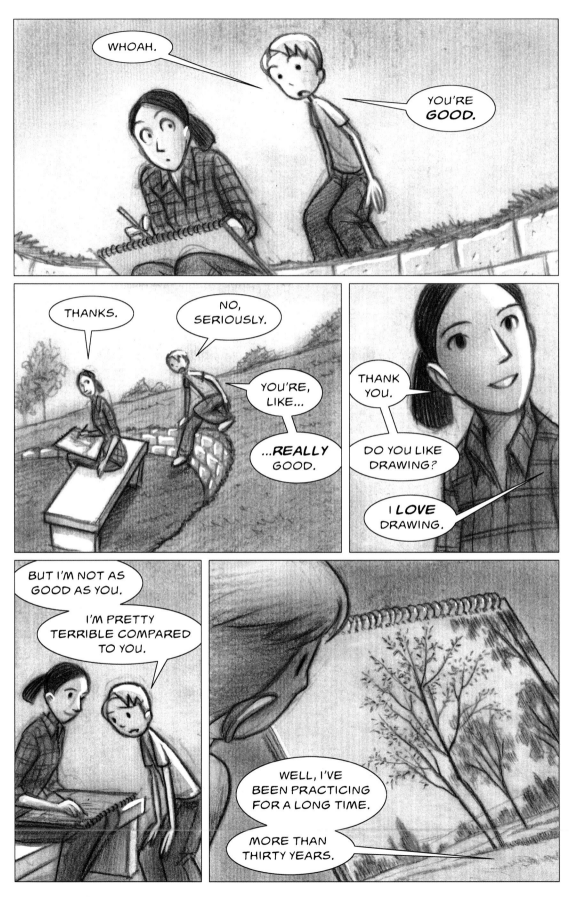

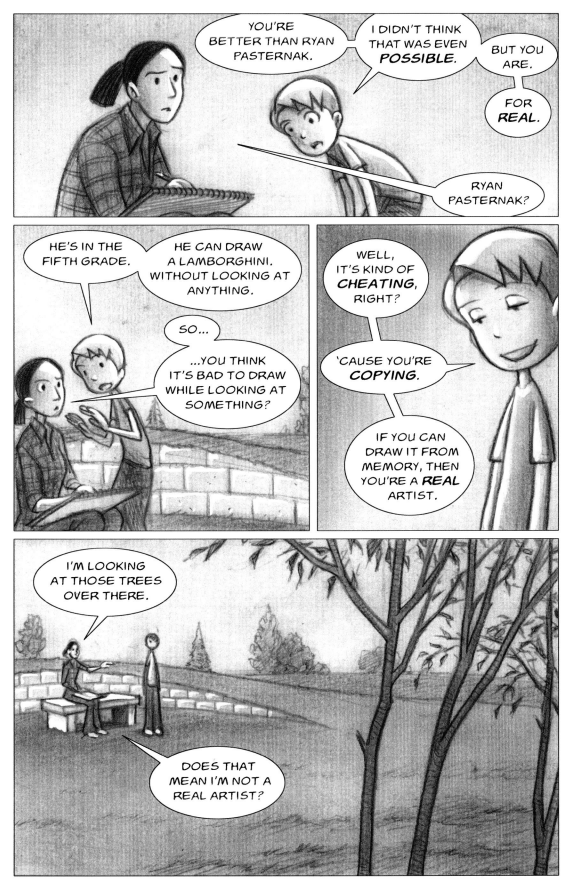

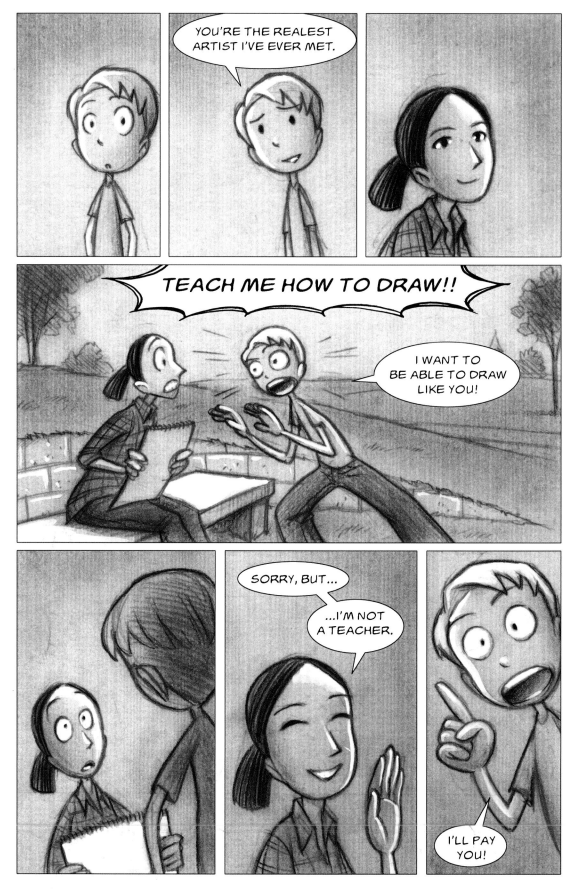

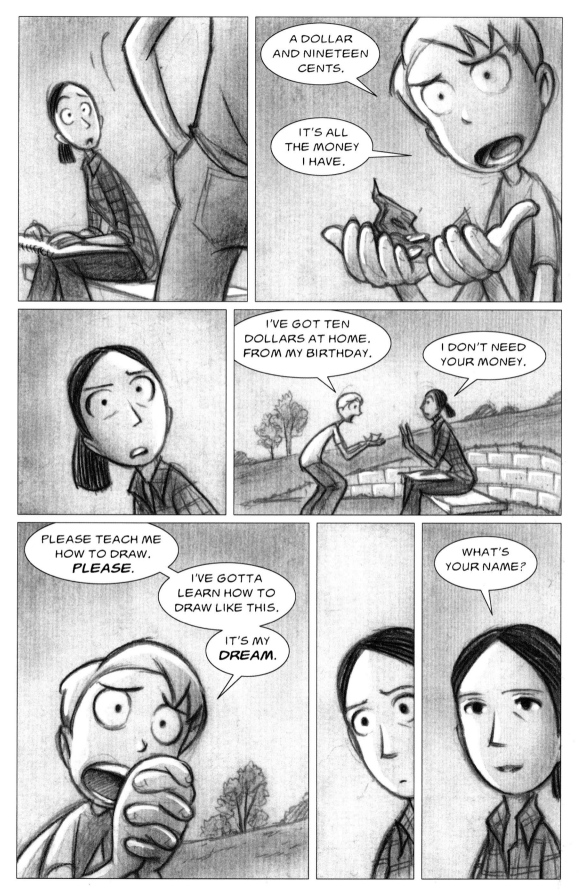

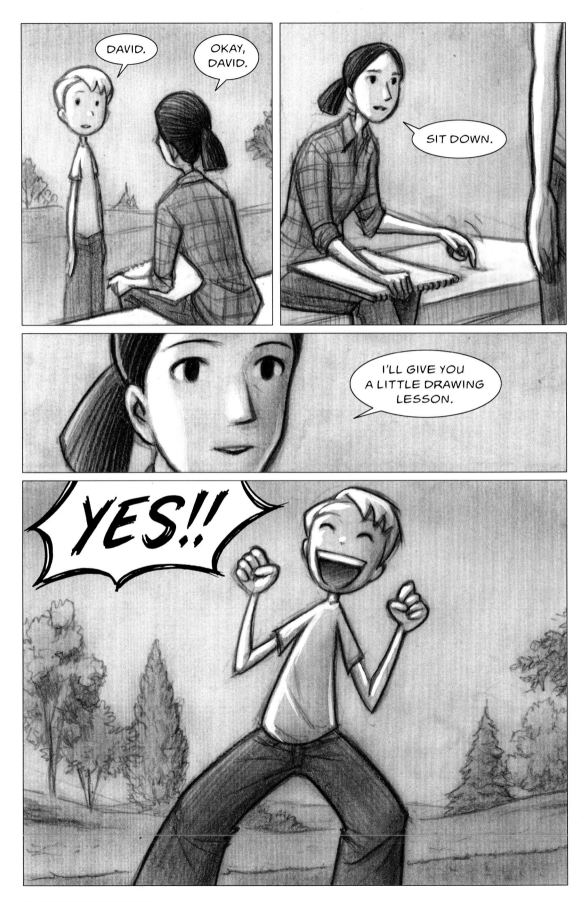

DRAWING WHAT YOU SEE

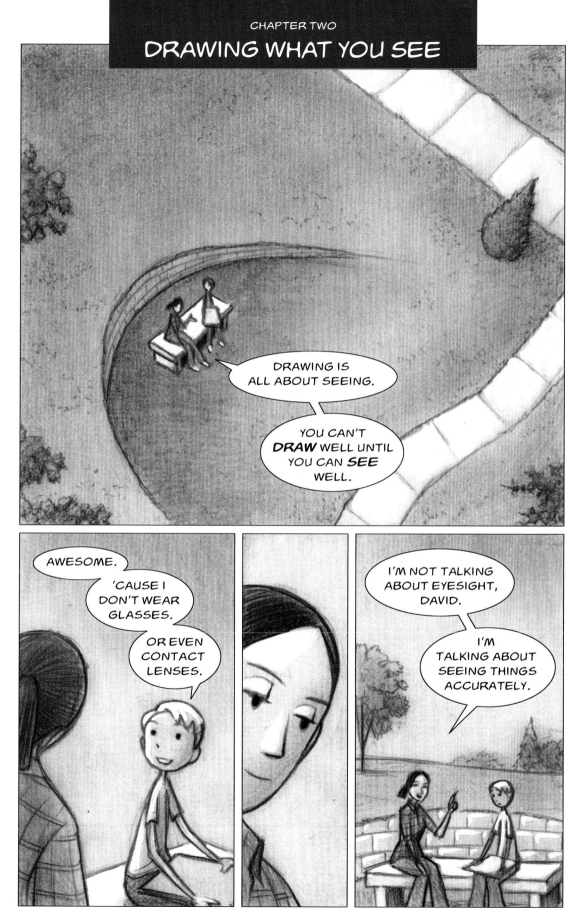

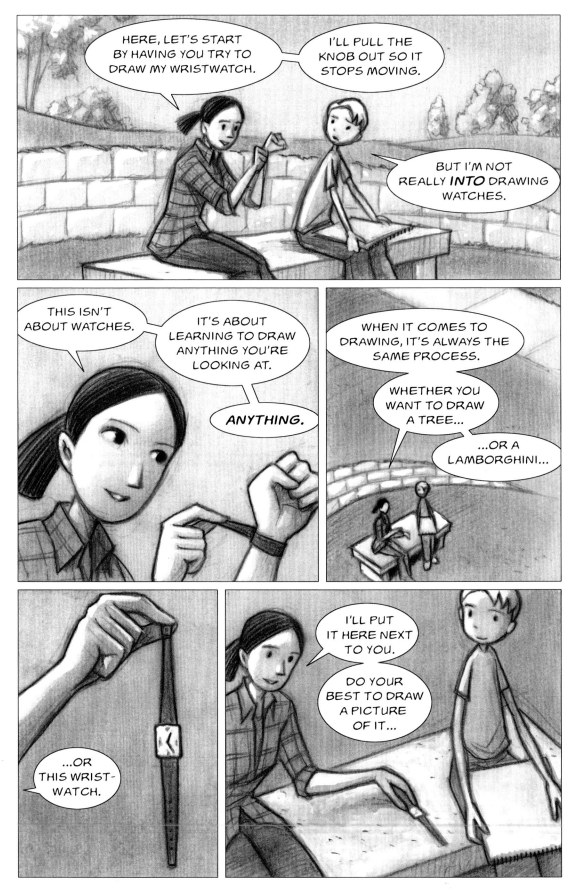

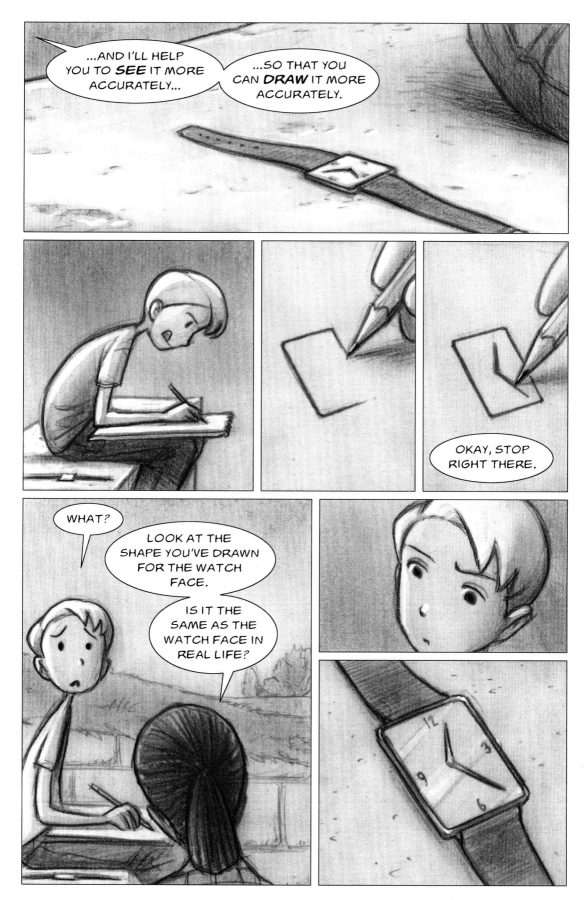

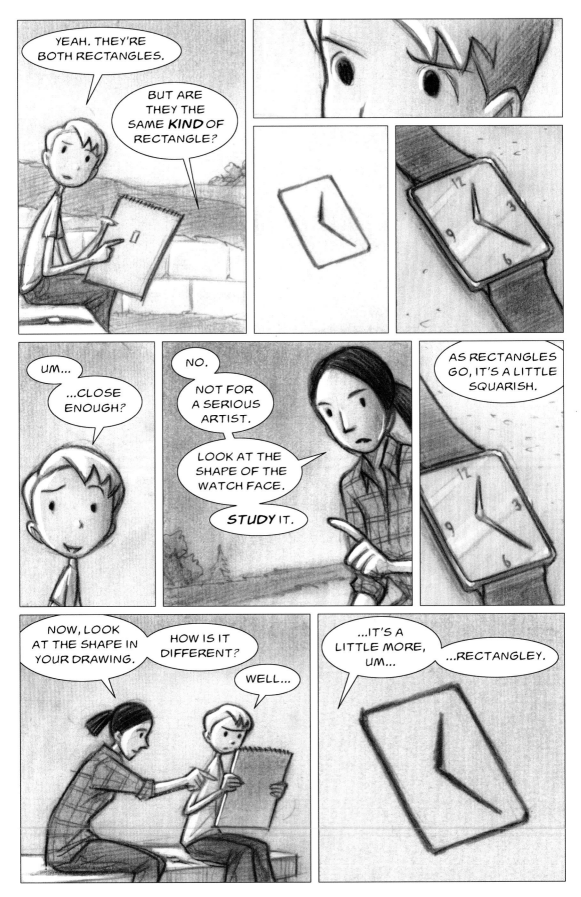

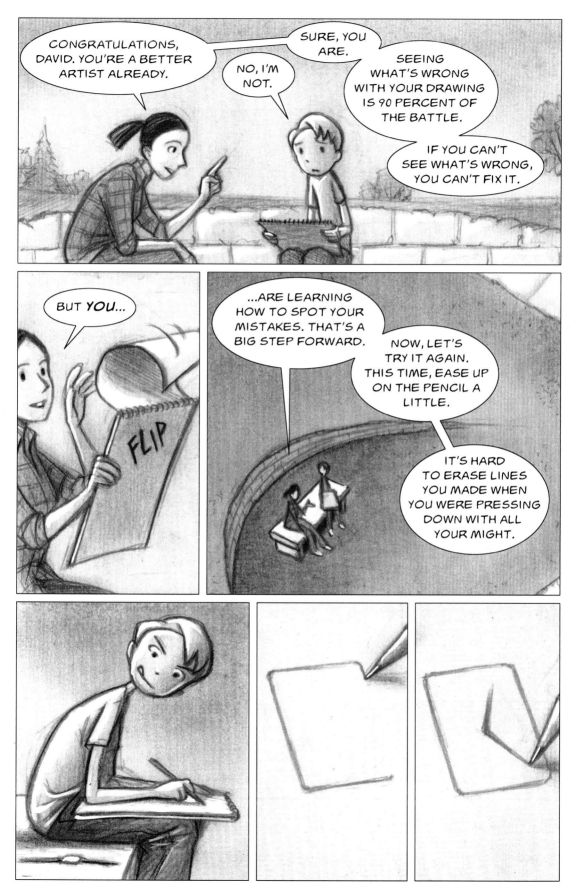

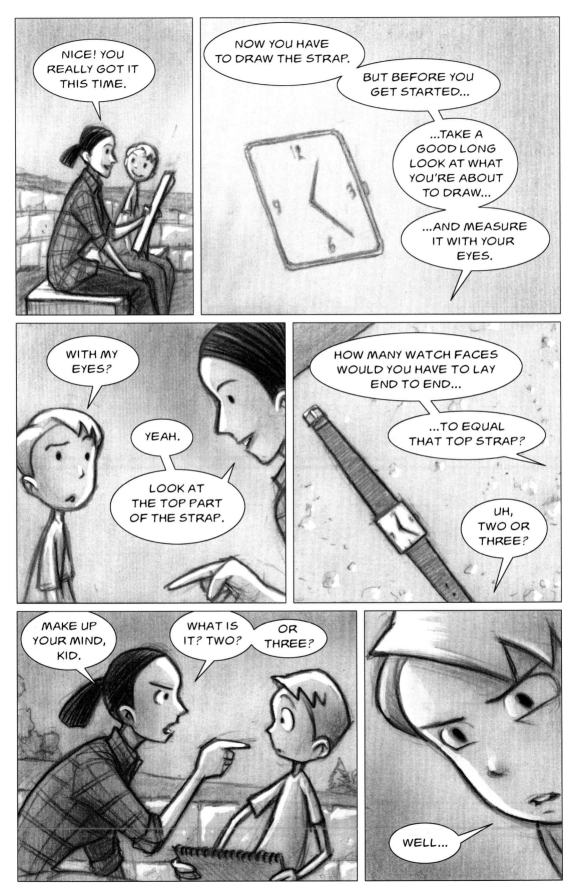

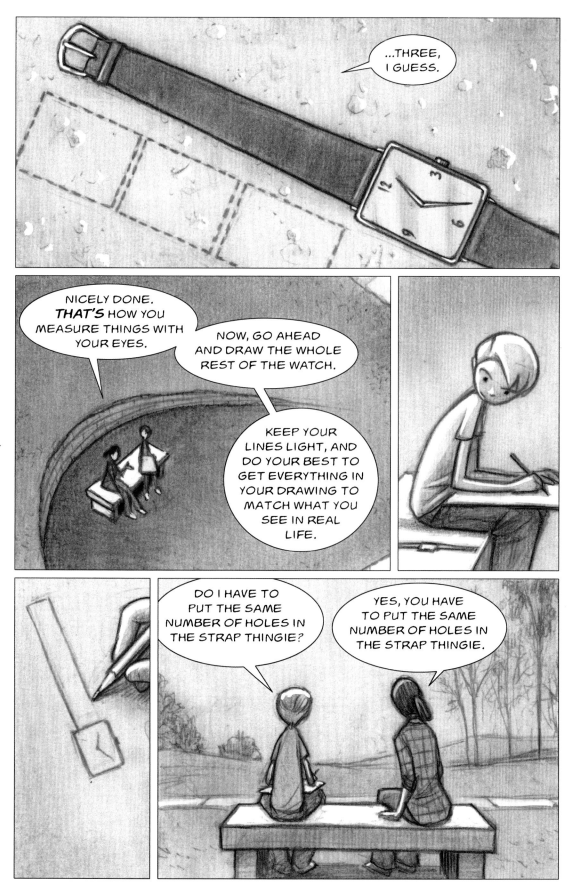

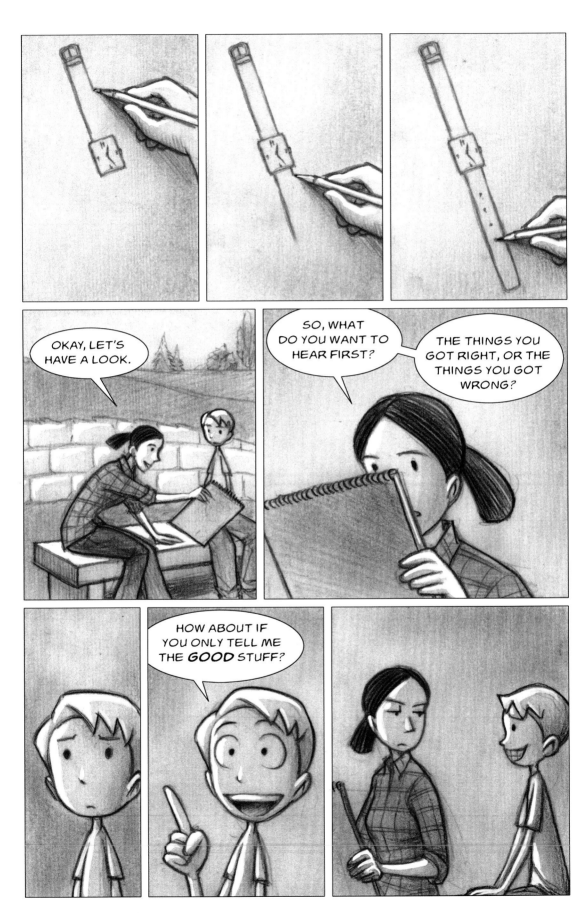

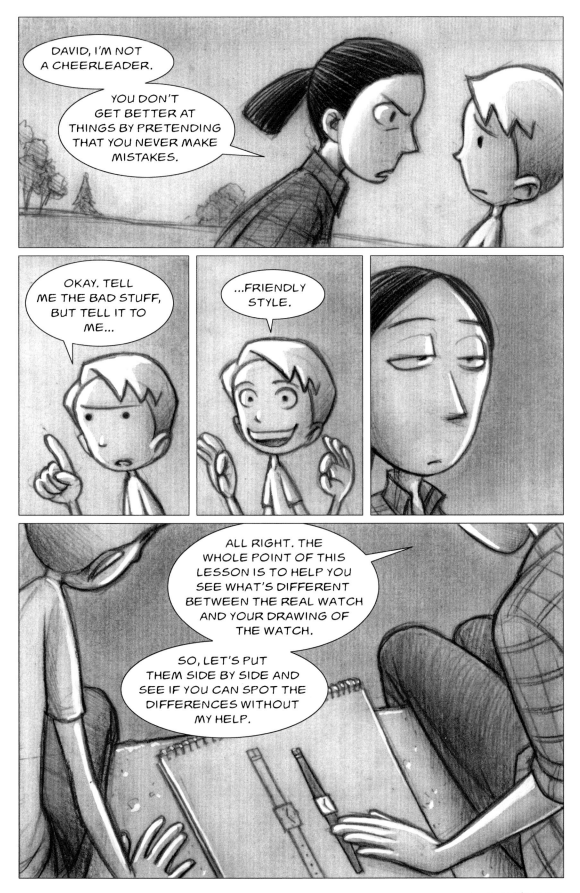

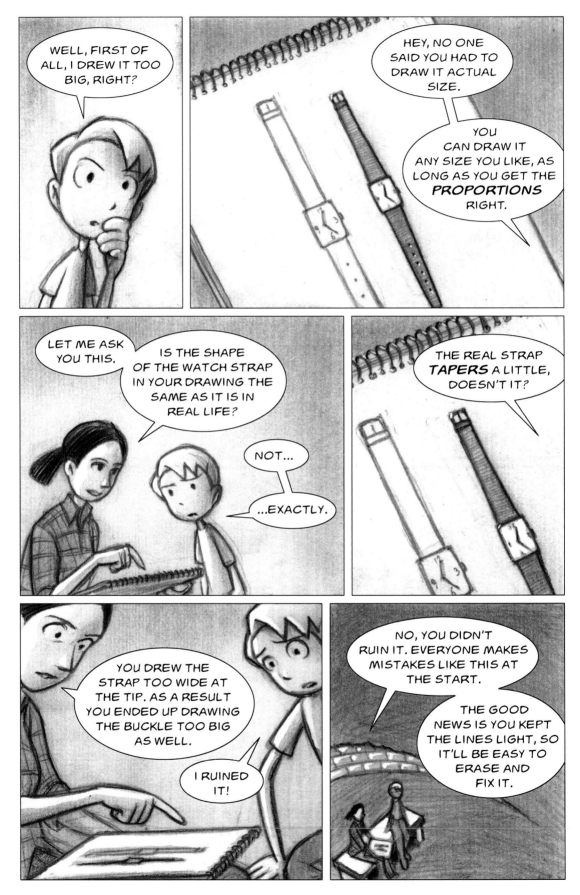

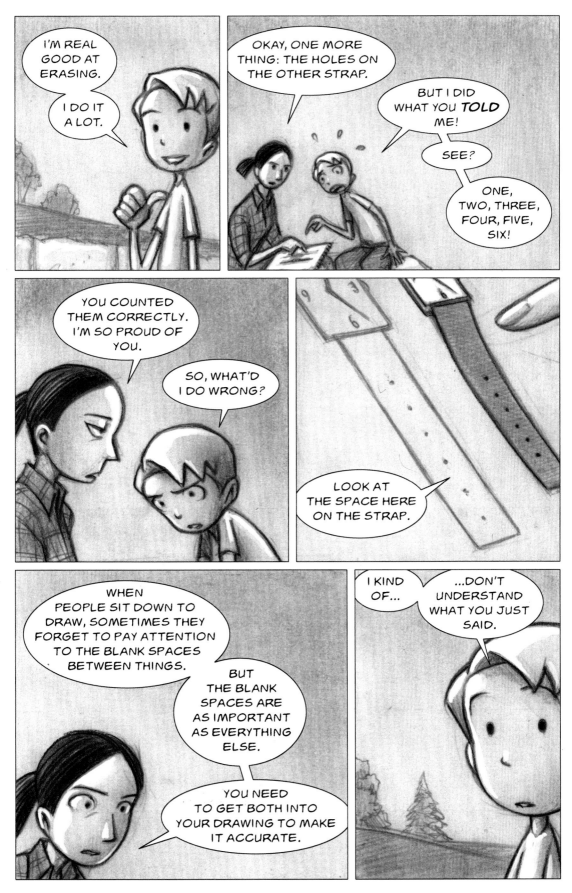

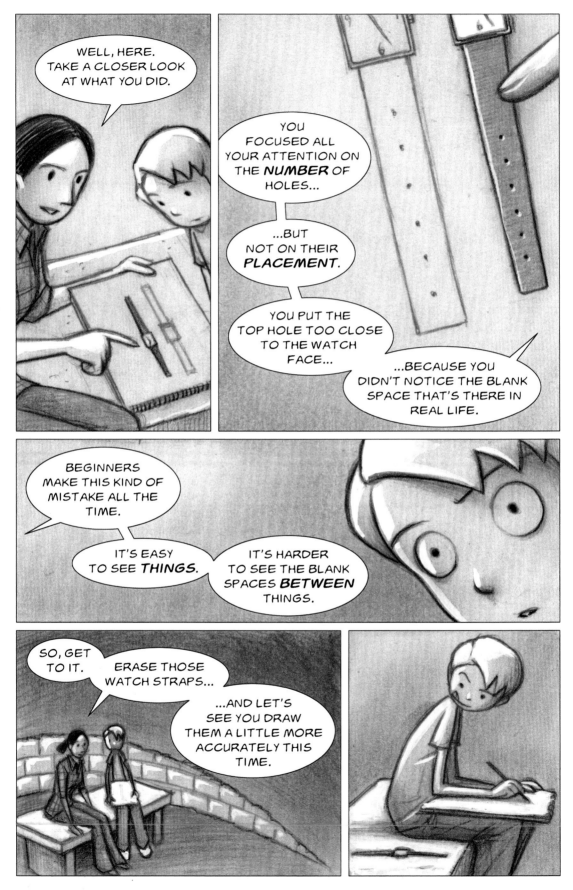

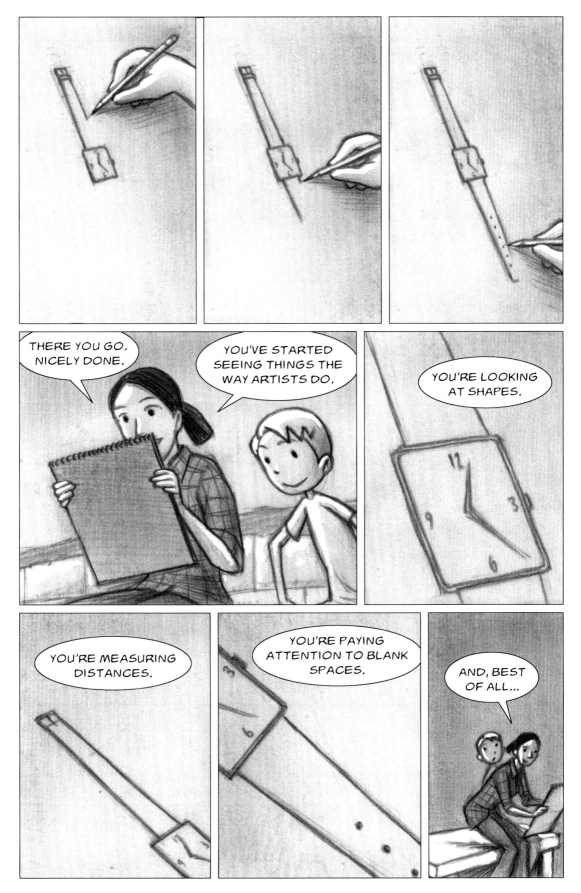

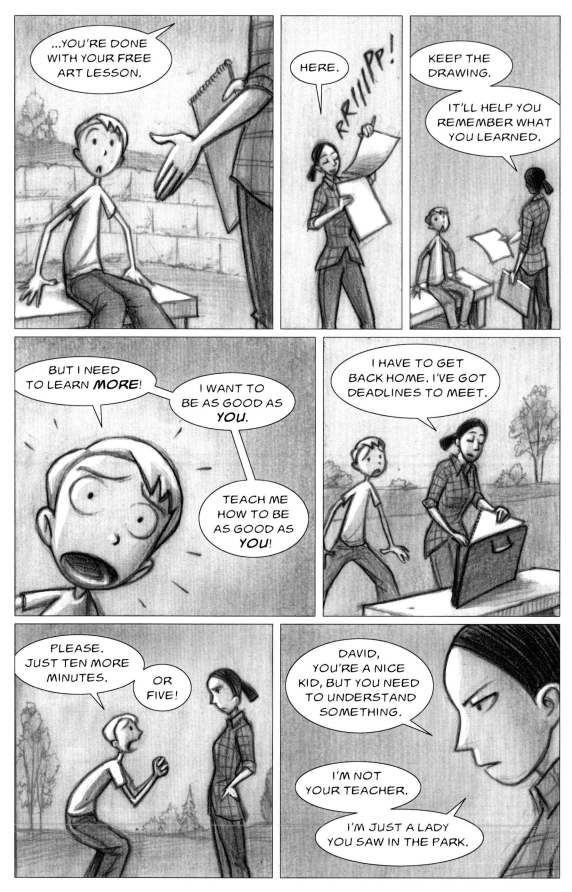

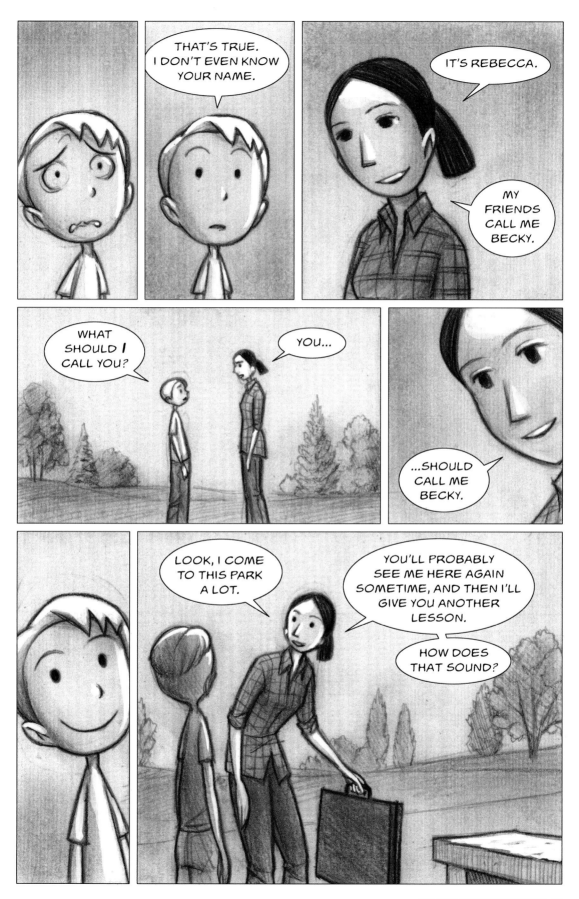

Now it's your turn. Find a simple object in your home and try to draw it. Pay special attention to the shapes and the blank spaces to make sure your drawing is as accurate as possible.

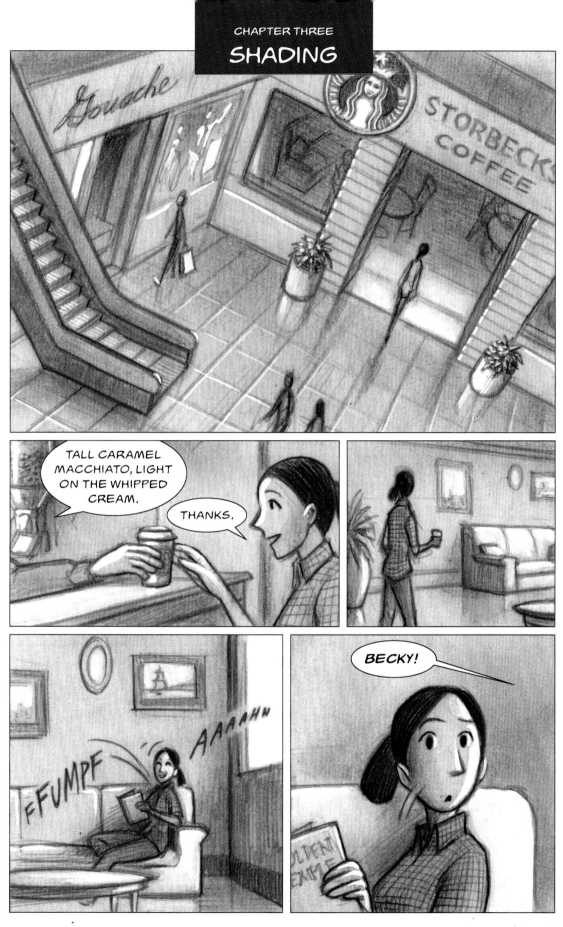

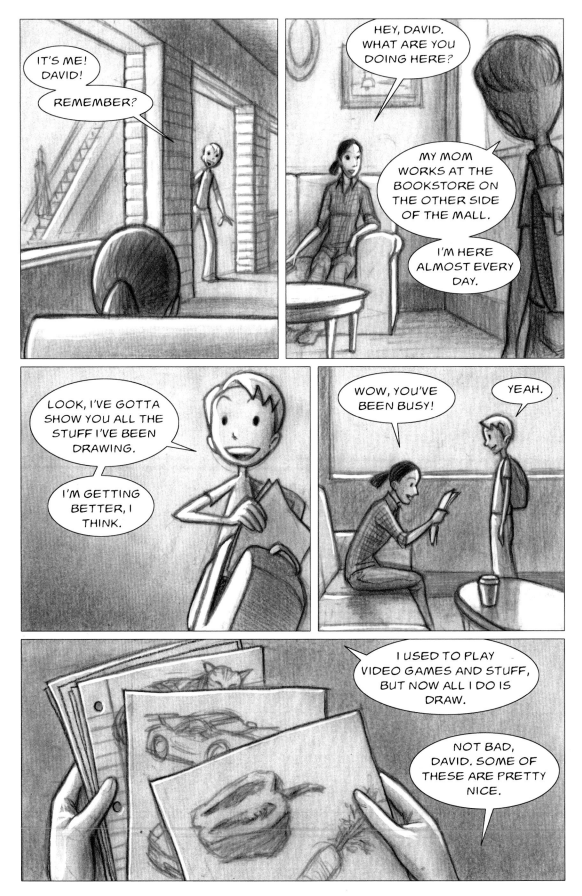

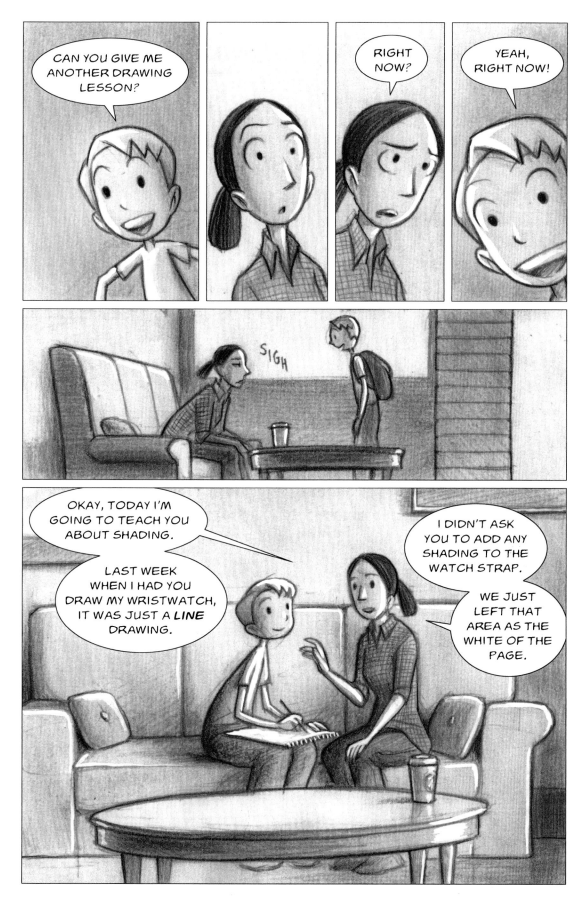

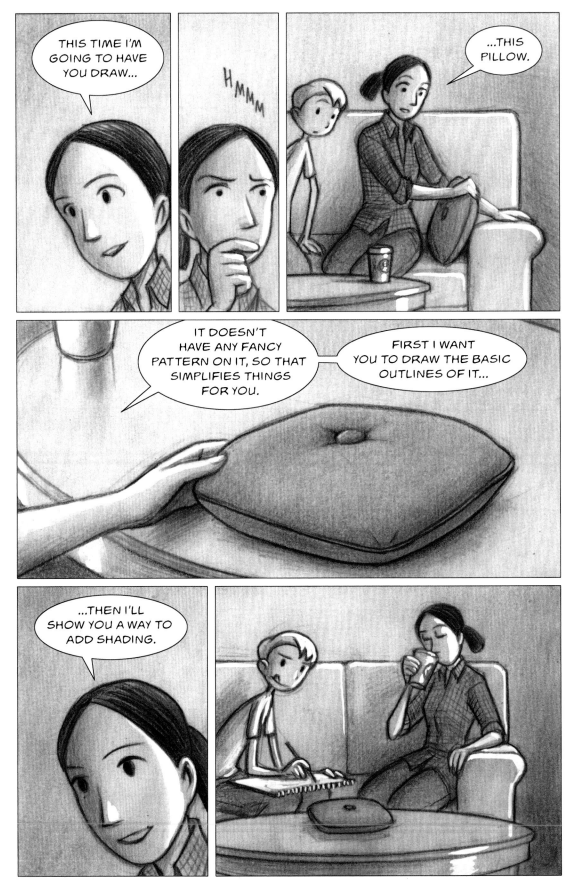

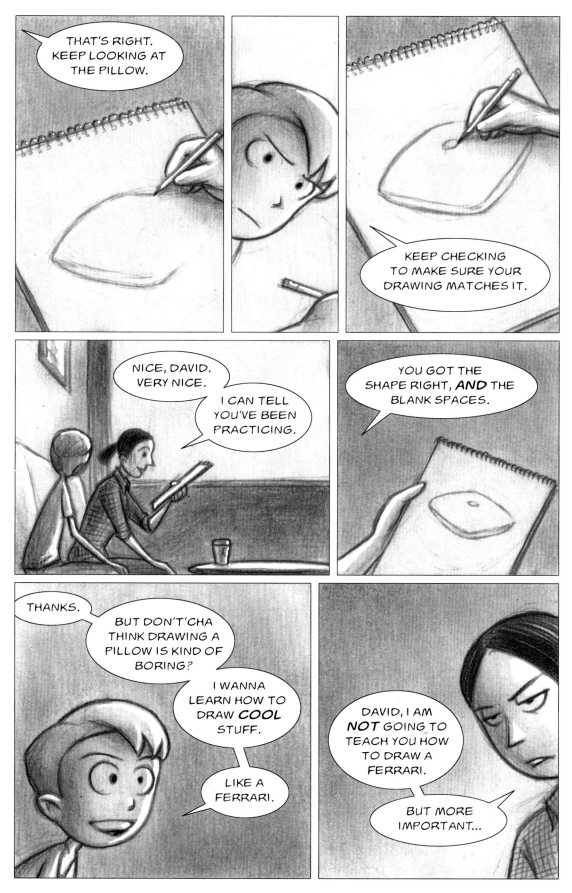

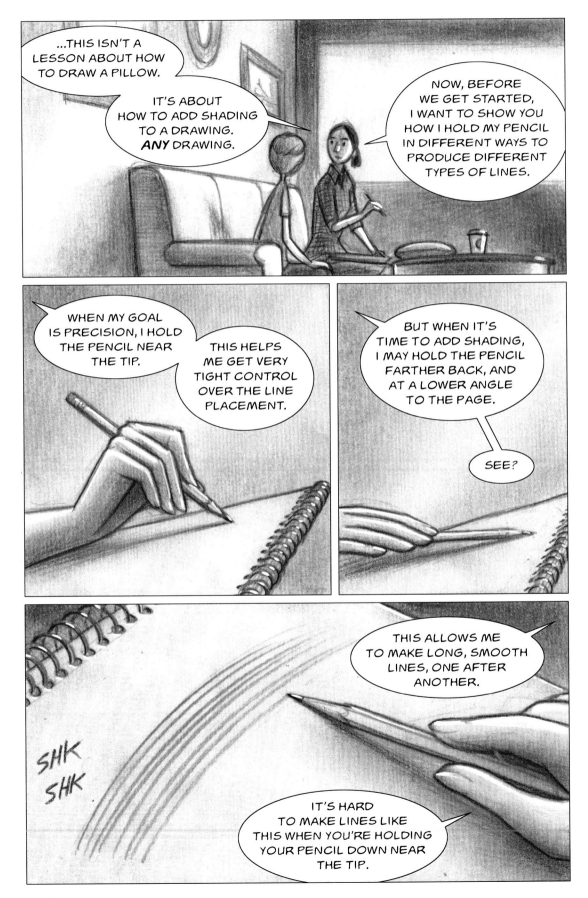

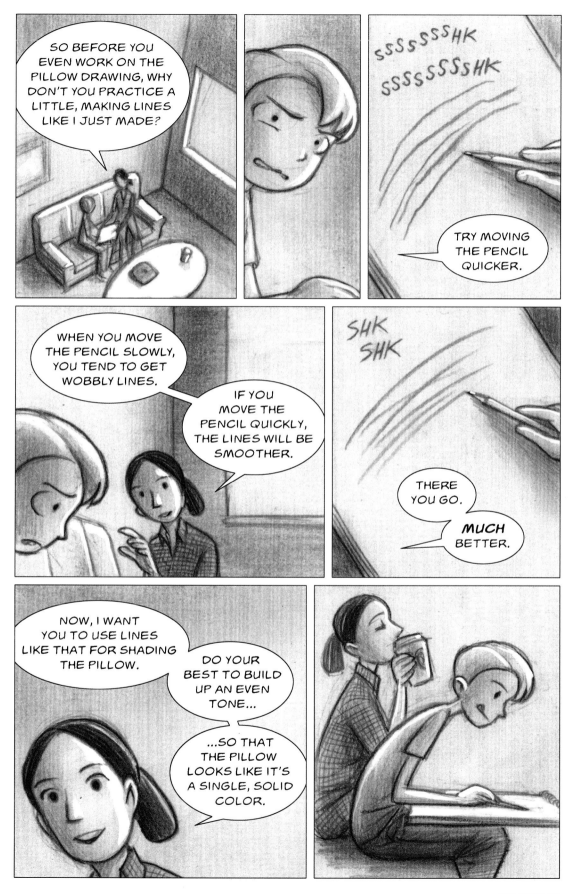

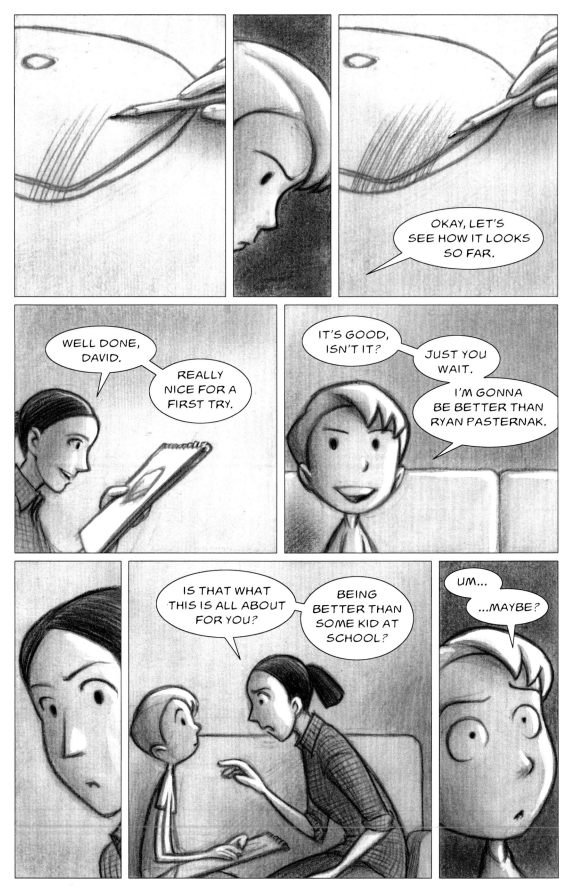

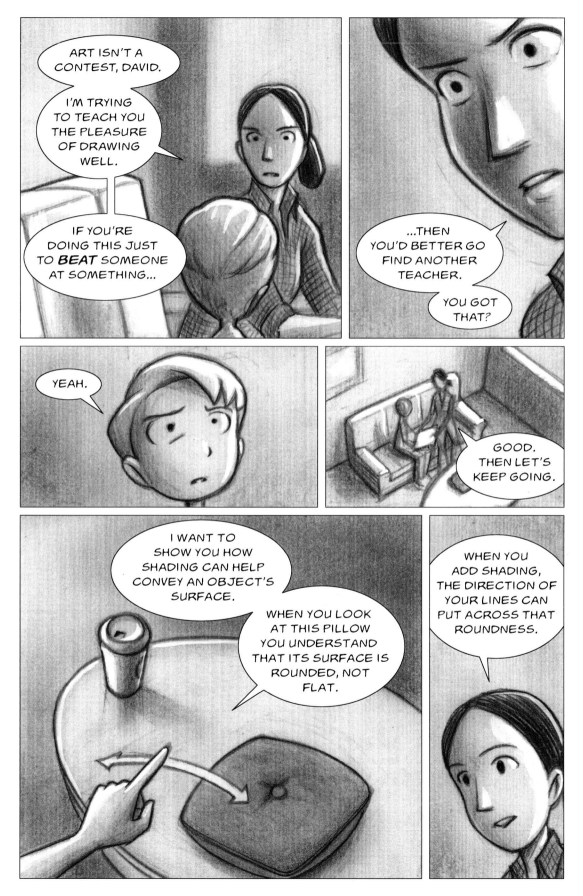

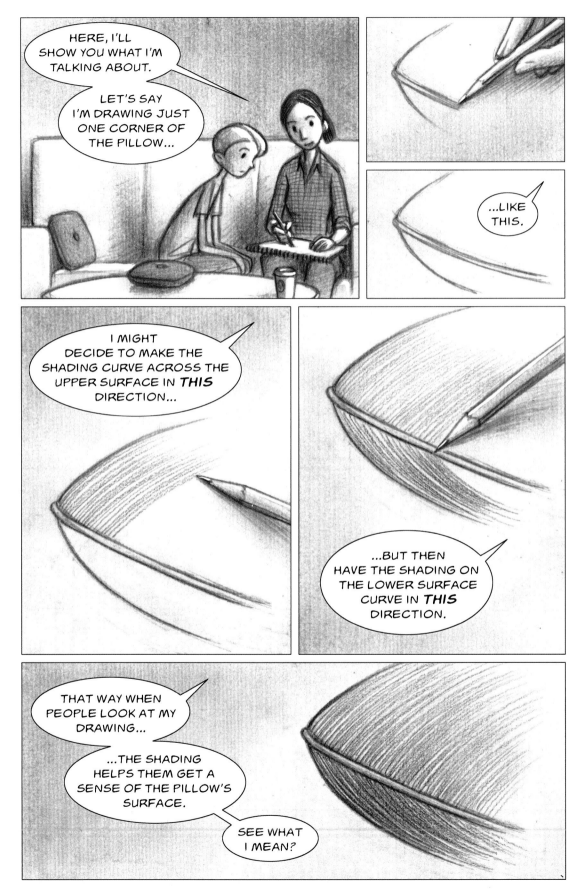

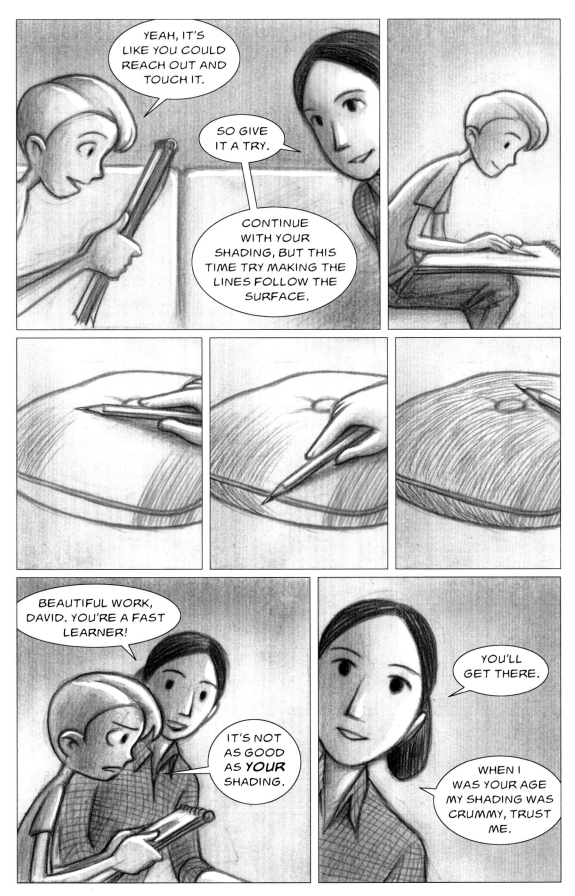

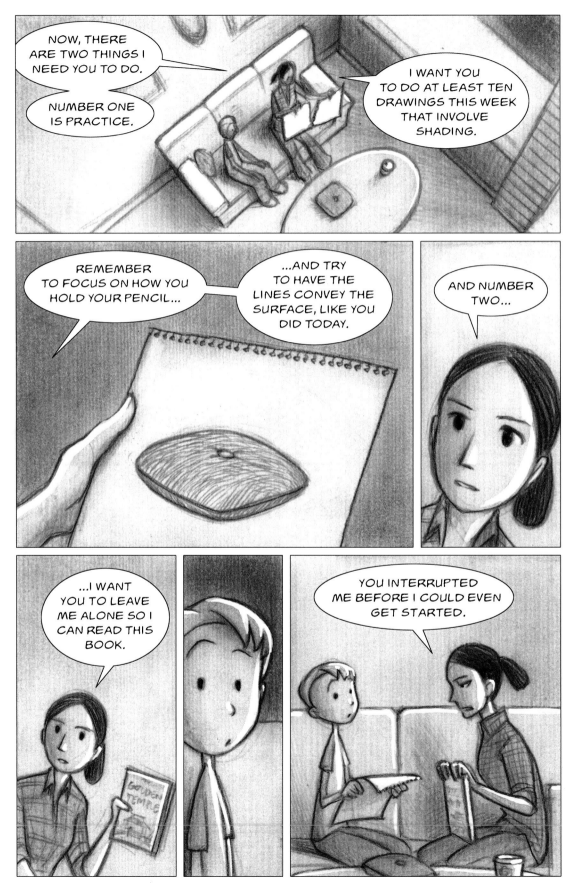

Find an object and try shading it with lines that reveal its surface. Remember how David learned to hold the pencil at a low angle to the page; see if you can hold it that way as you add the shading.

CHAPTER FOUR
BEGINNING WITH A LOOSE SKETCH

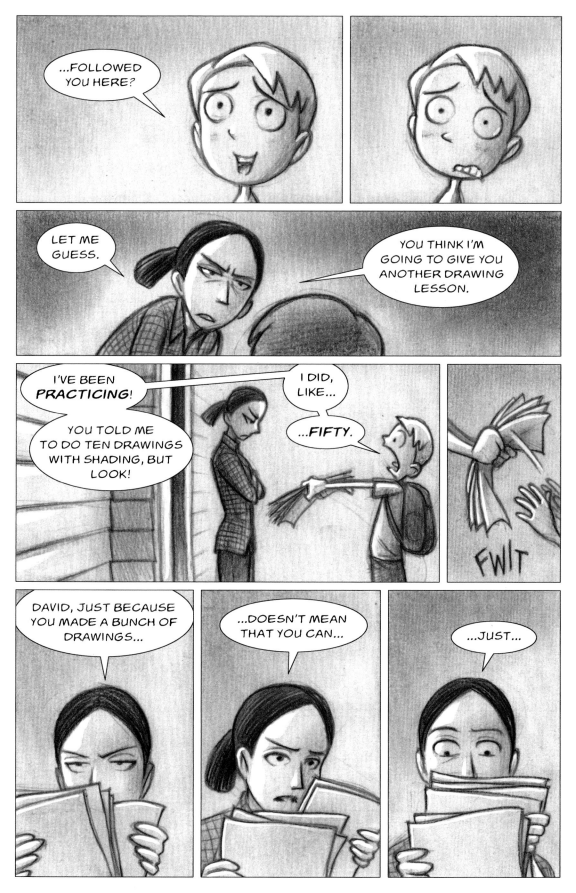

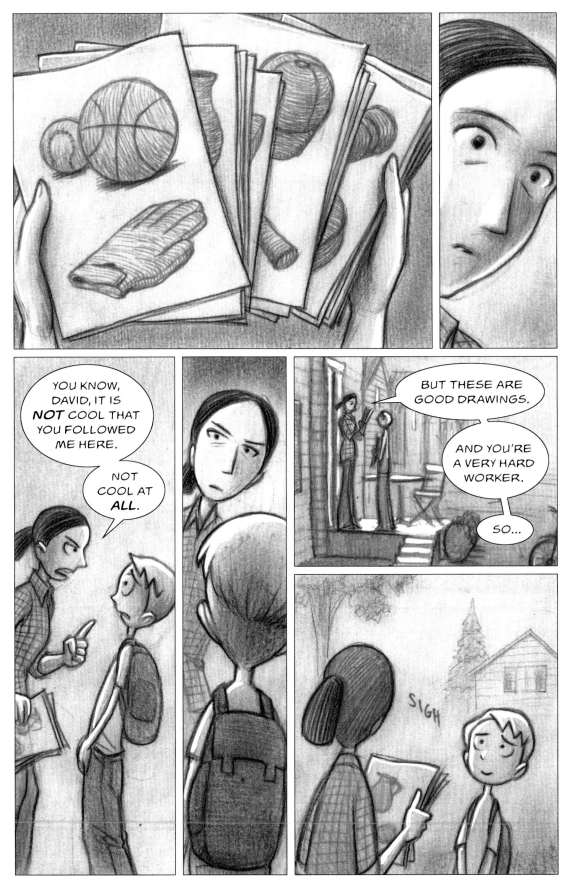

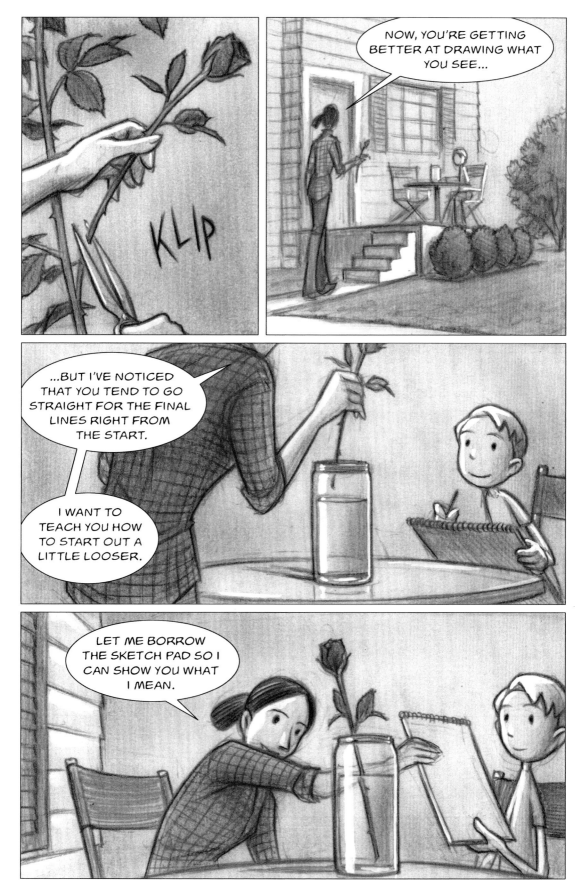

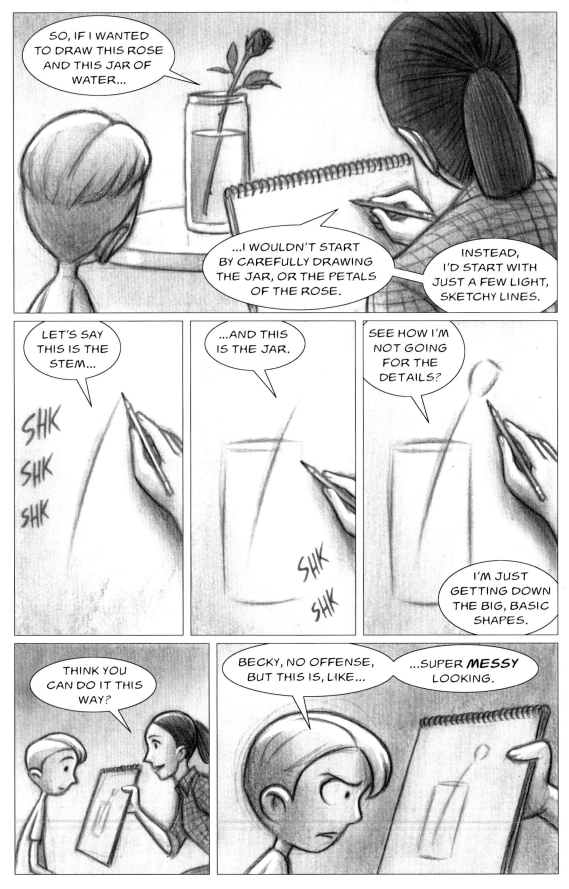

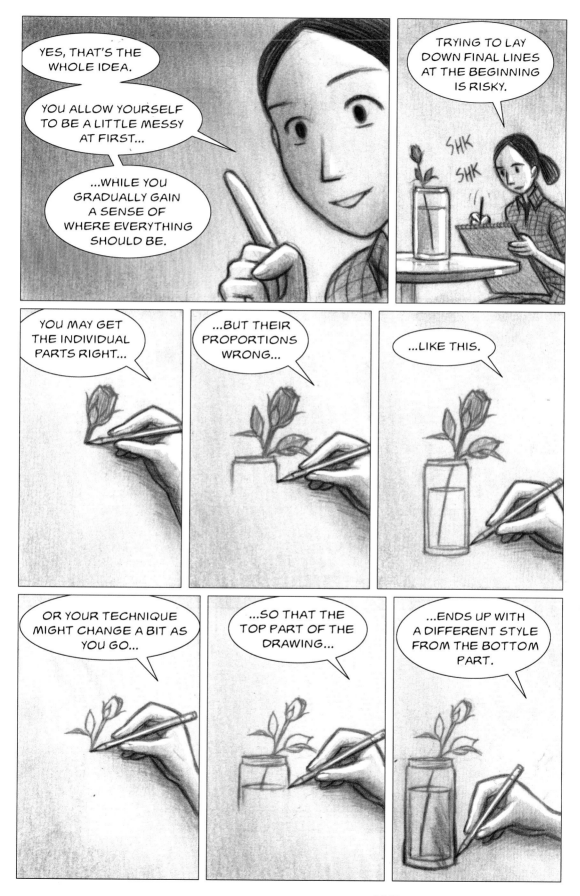

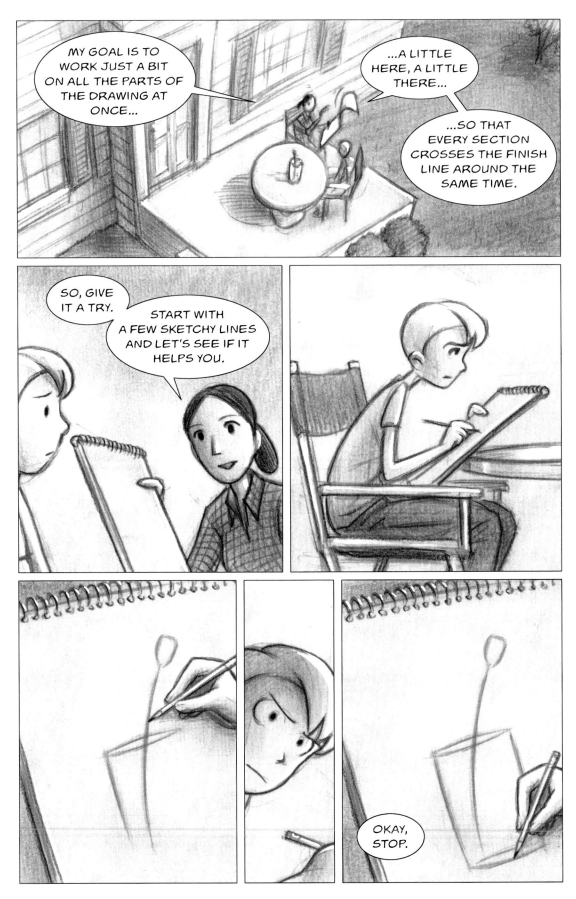

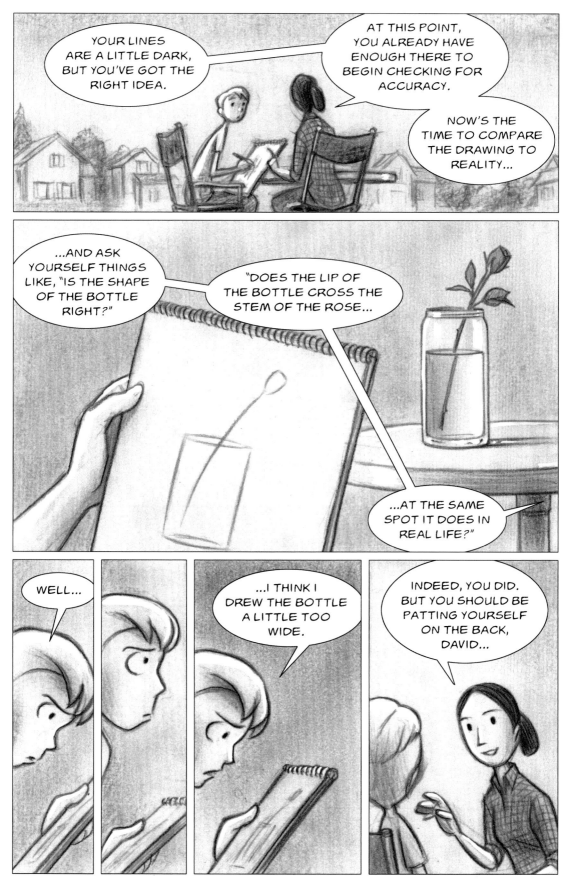

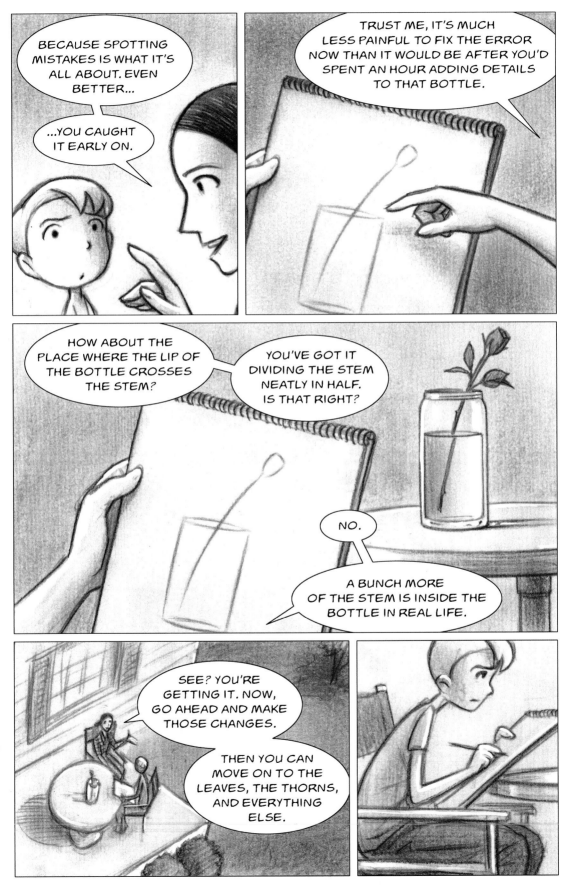

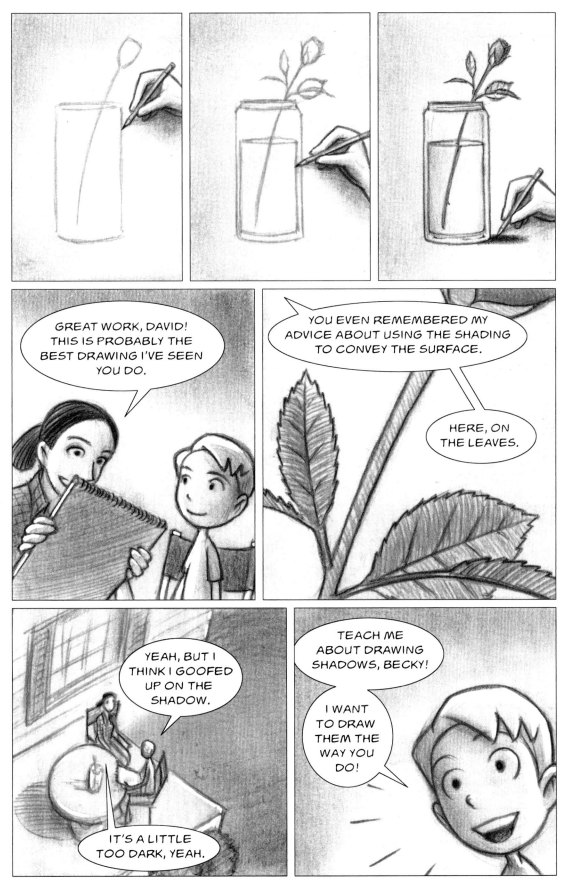

Try drawing something using light, sketchy lines at first, then gradually working toward final details. Instead of spending lots of time on a single area, do your best to split your time evenly throughout the piece, bringing everything to completion around the same time.

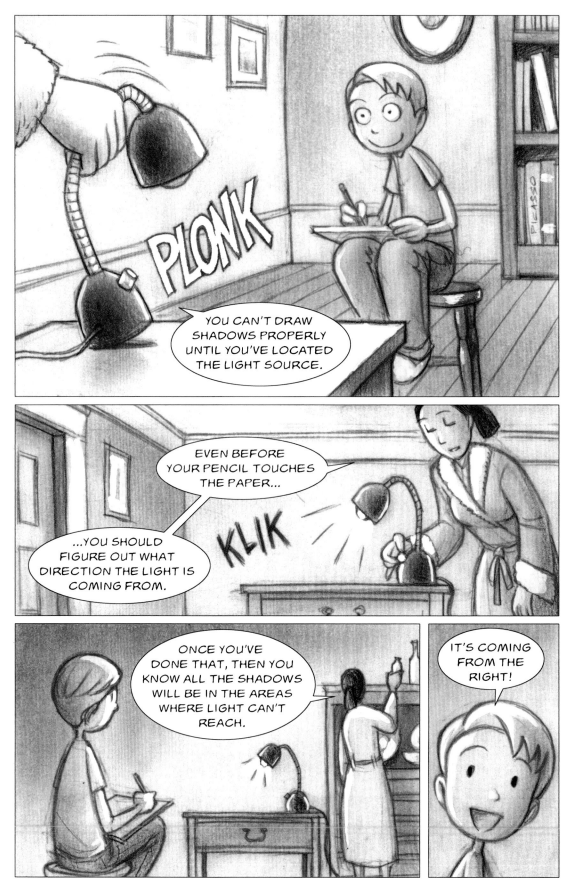

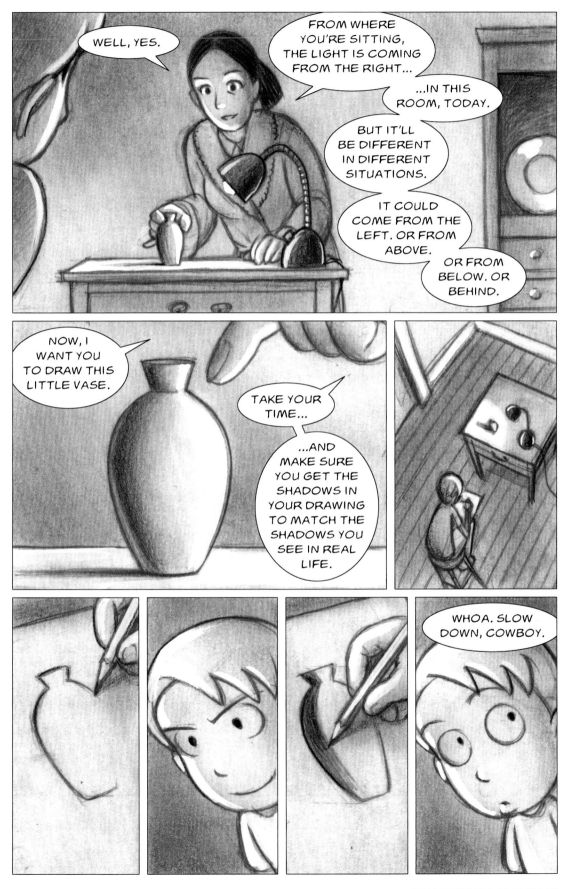

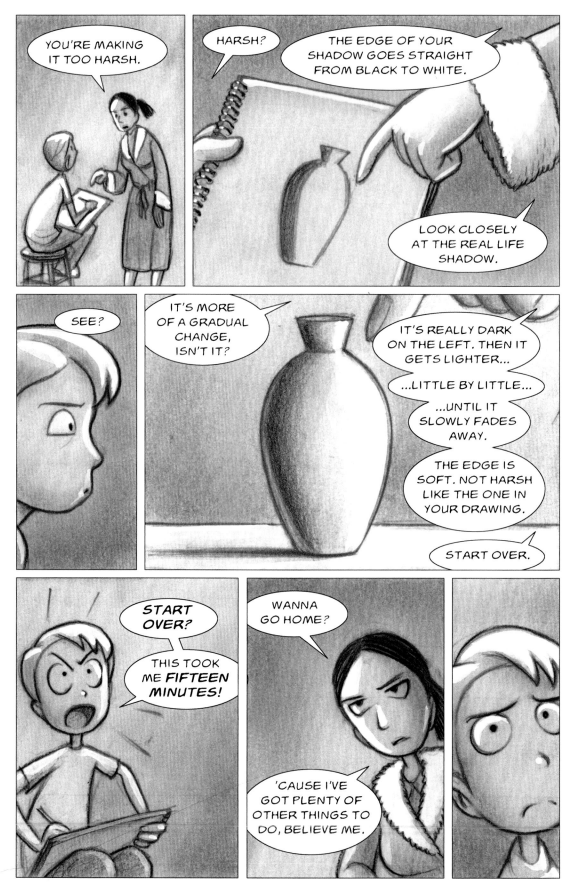

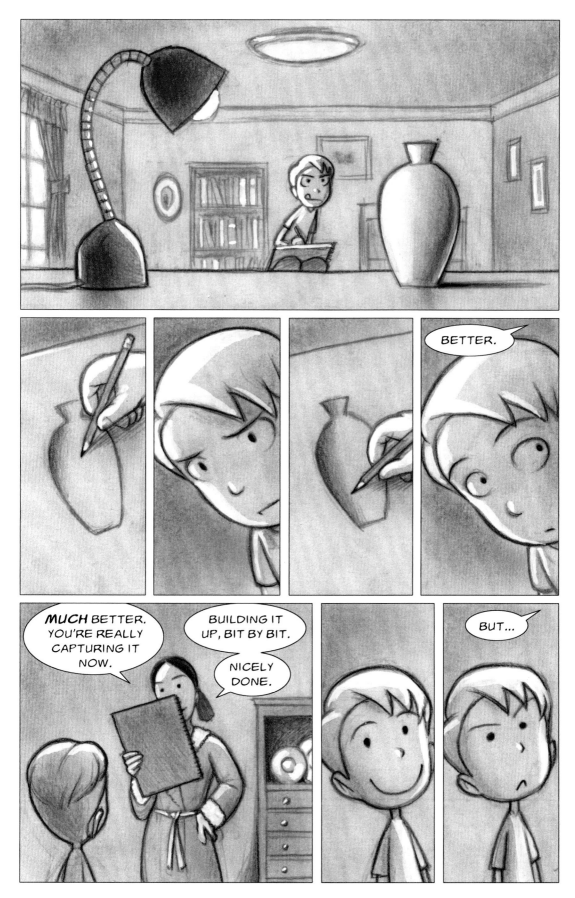

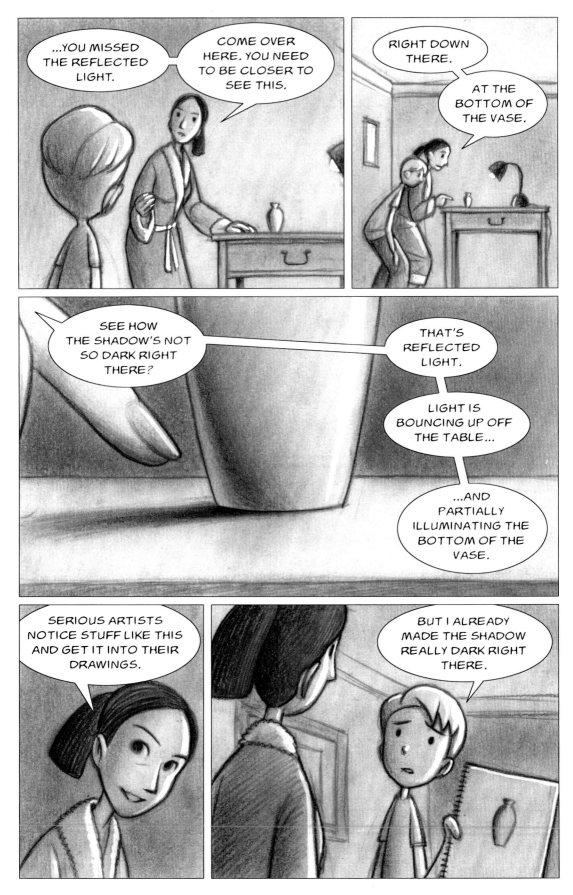

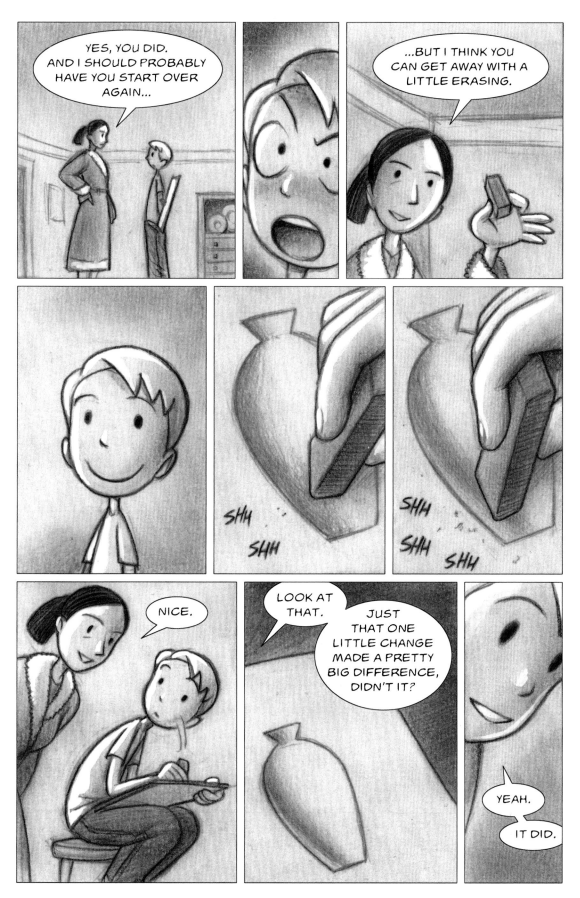

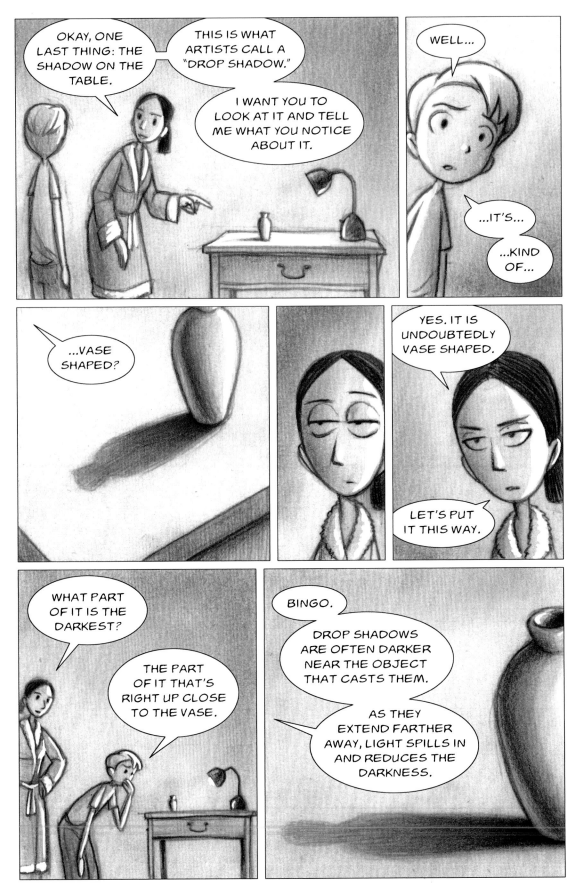

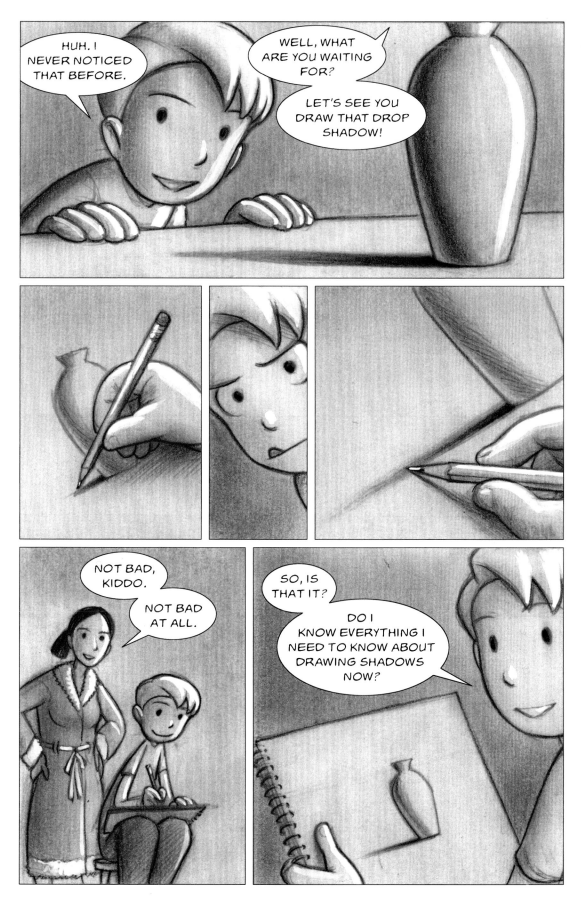

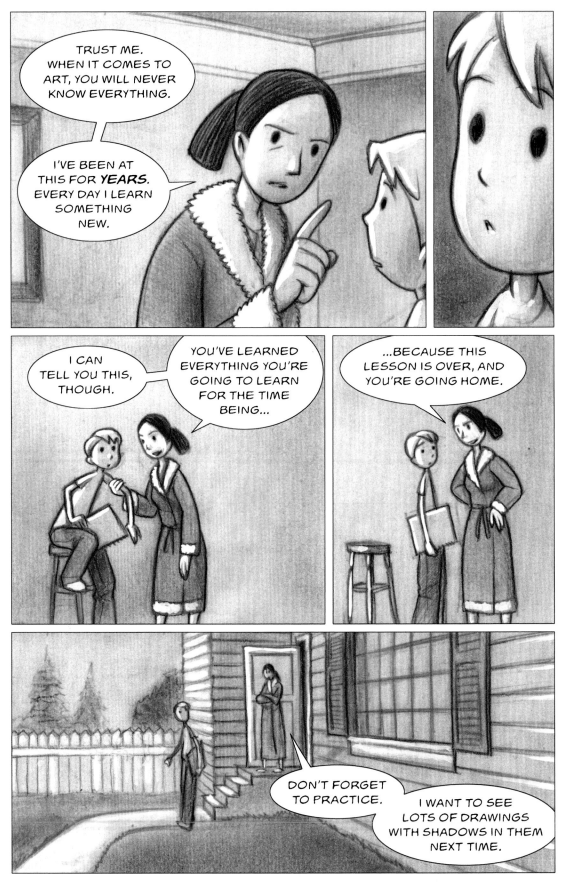

Do a drawing of an object that is illuminated by a single, clear light source. Pay special attention to gradual changes in darkness within the shadows, whether they occur on the object or in the drop shadow.

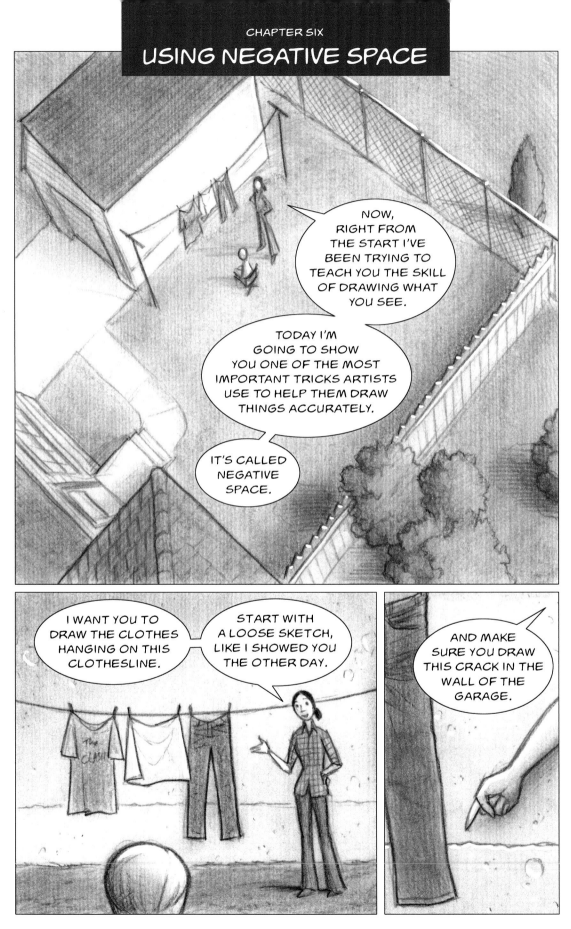

CHAPTER SIX
USING NEGATIVE SPACE

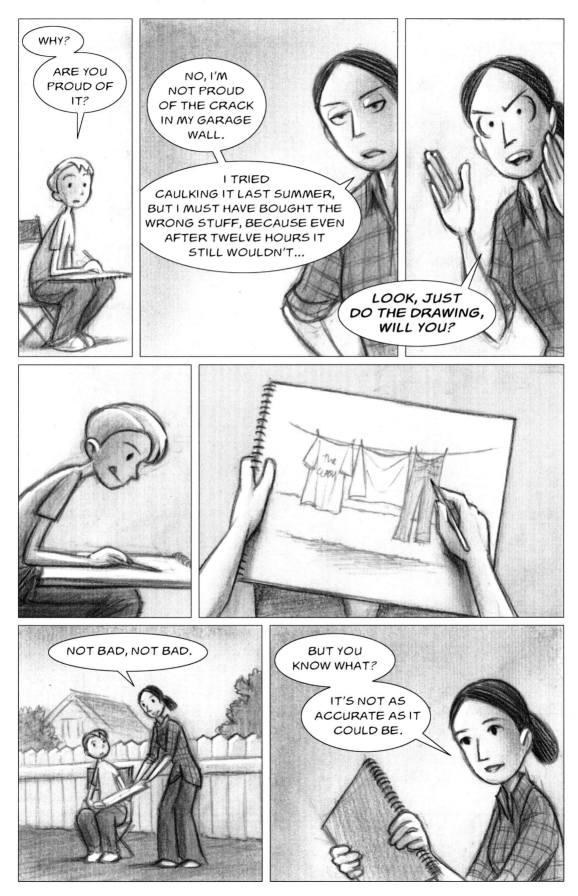

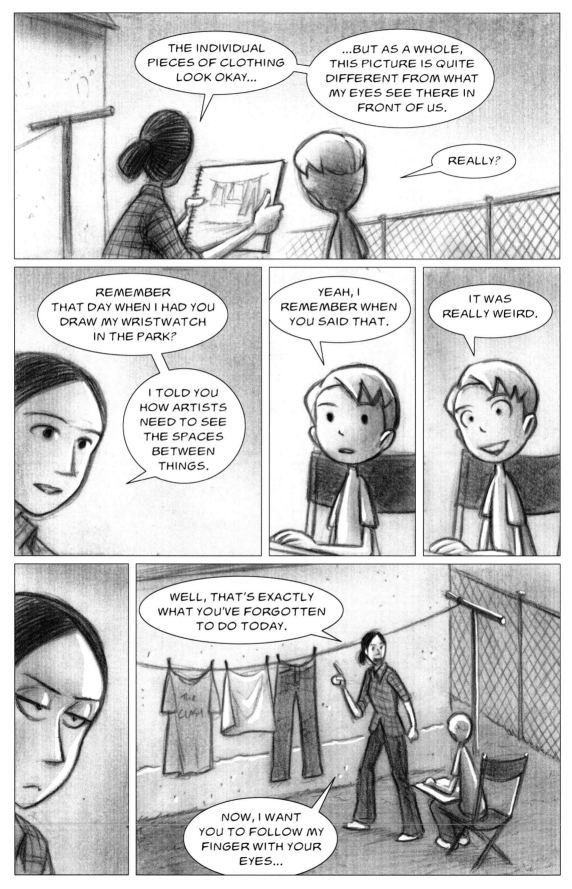

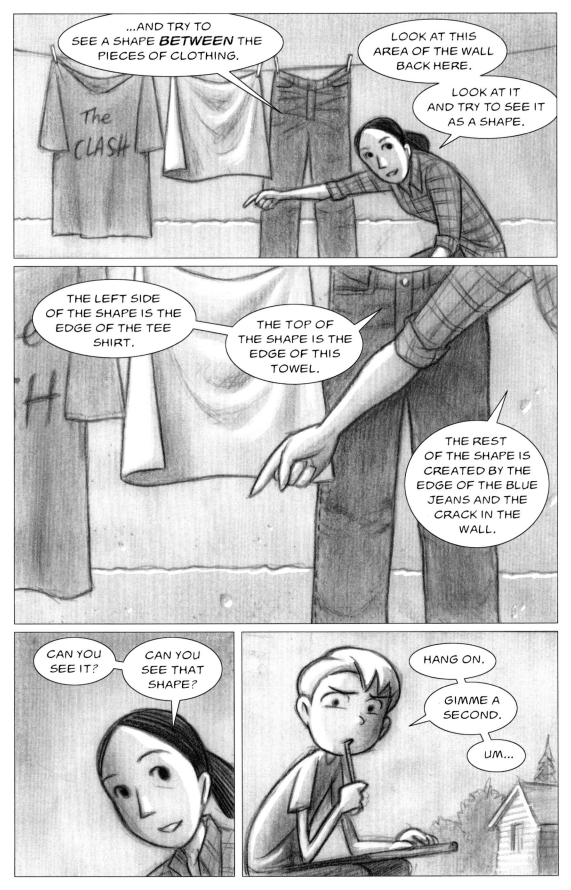

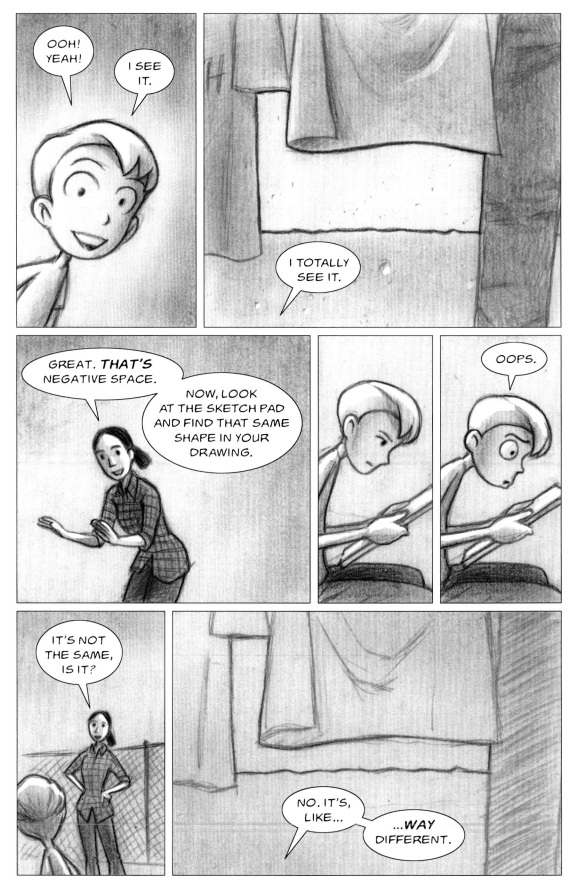

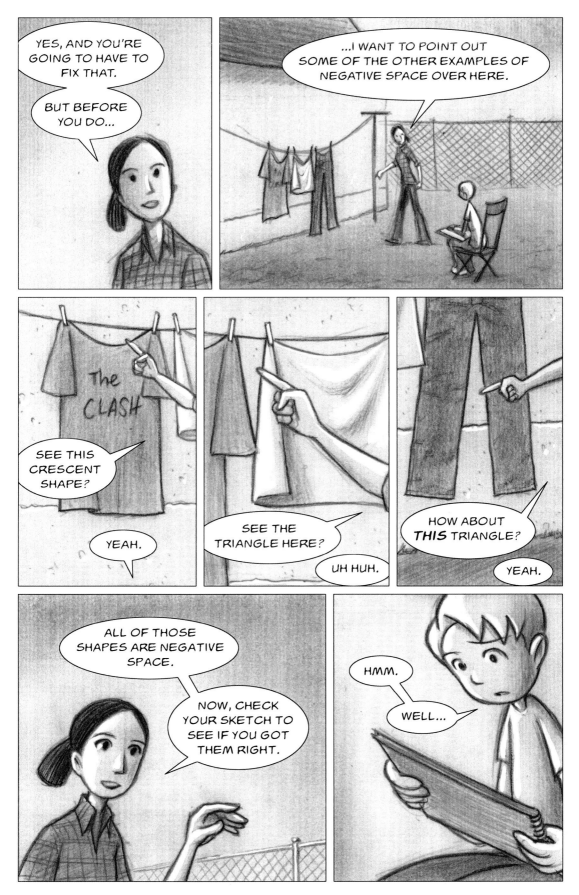

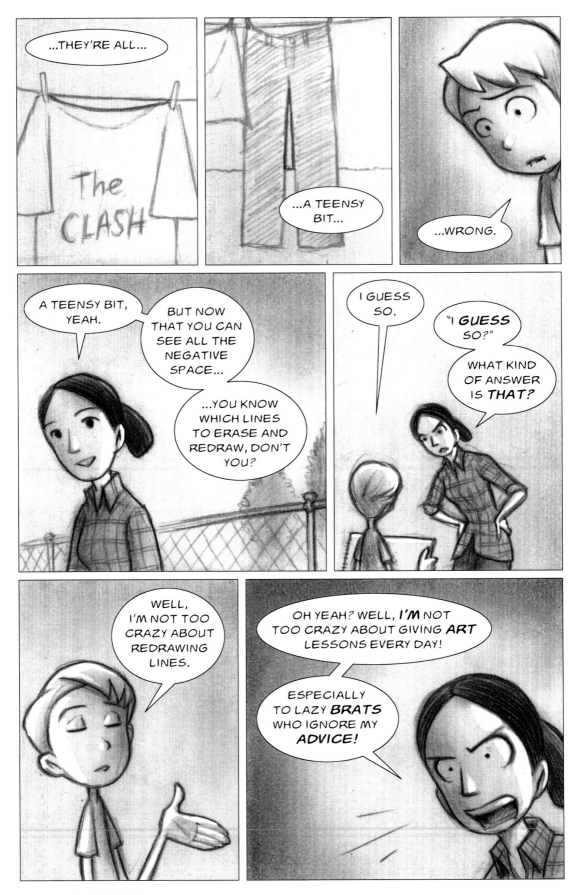

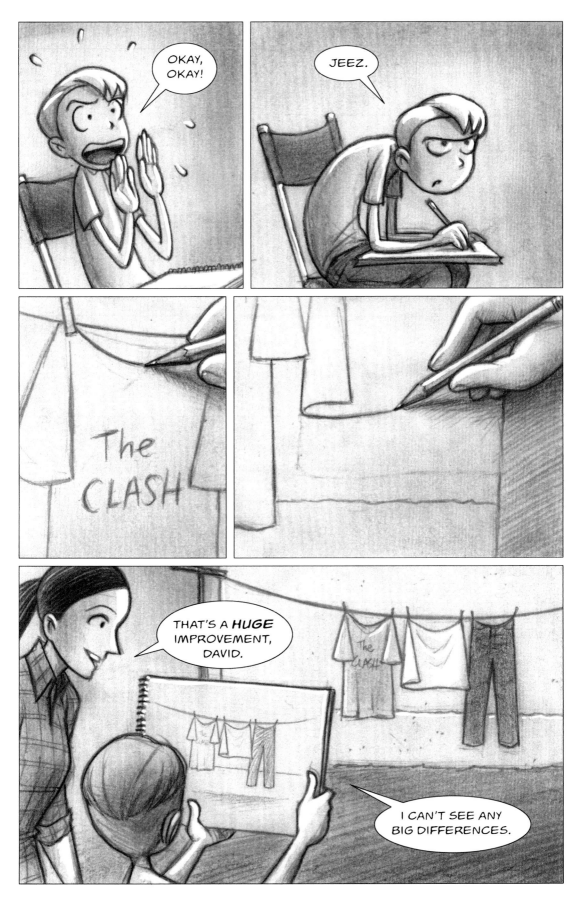

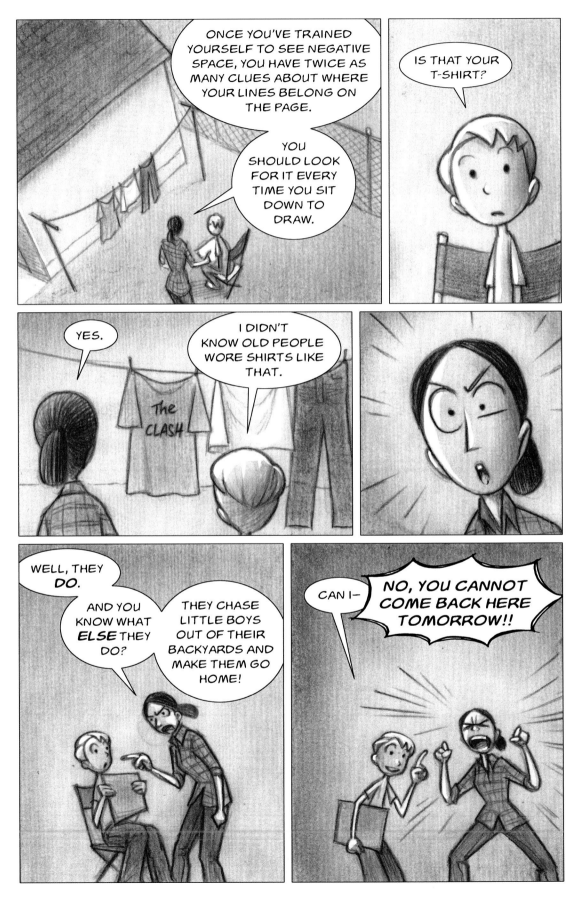

Draw an object or location in which you can observe areas of negative space. Use the blank spaces to help you place lines accurately and to get shapes in your drawing to more closely resemble the ones you see in real life.

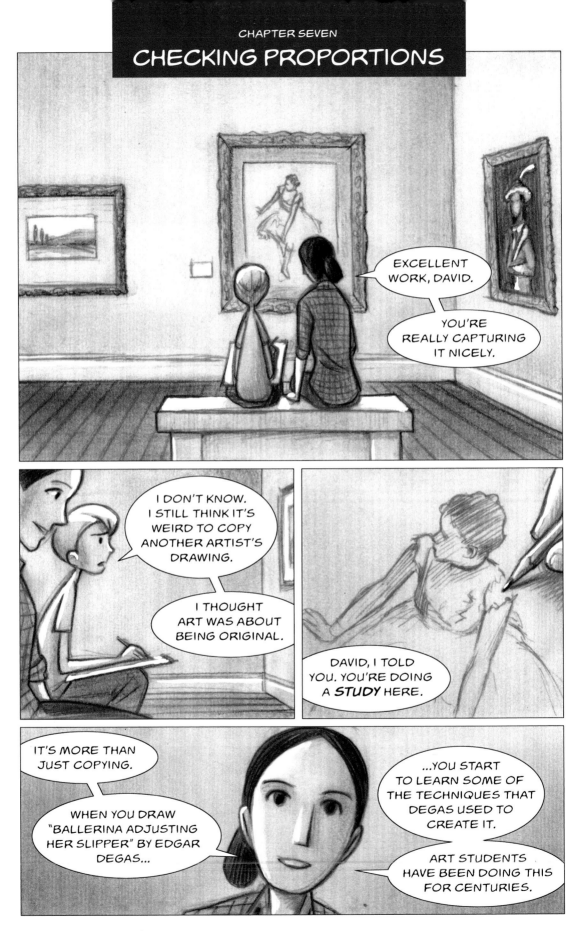

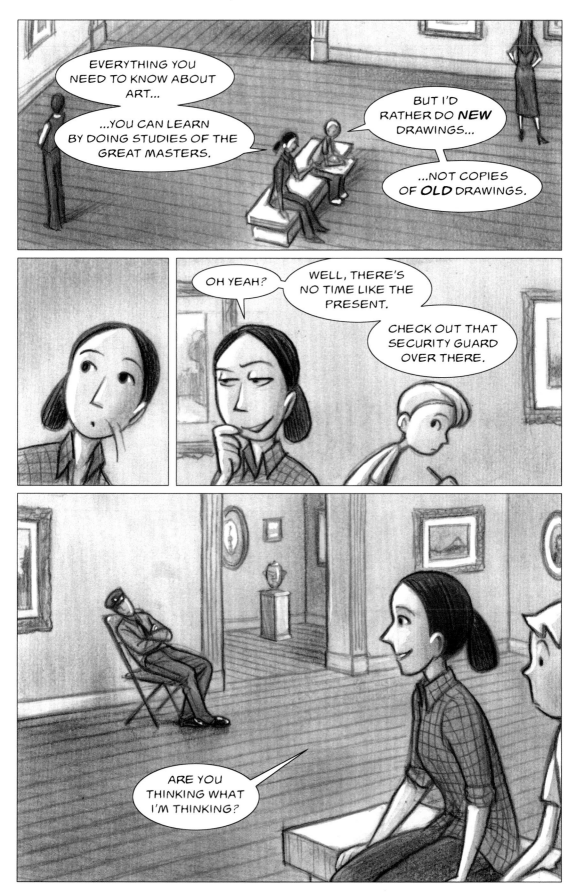

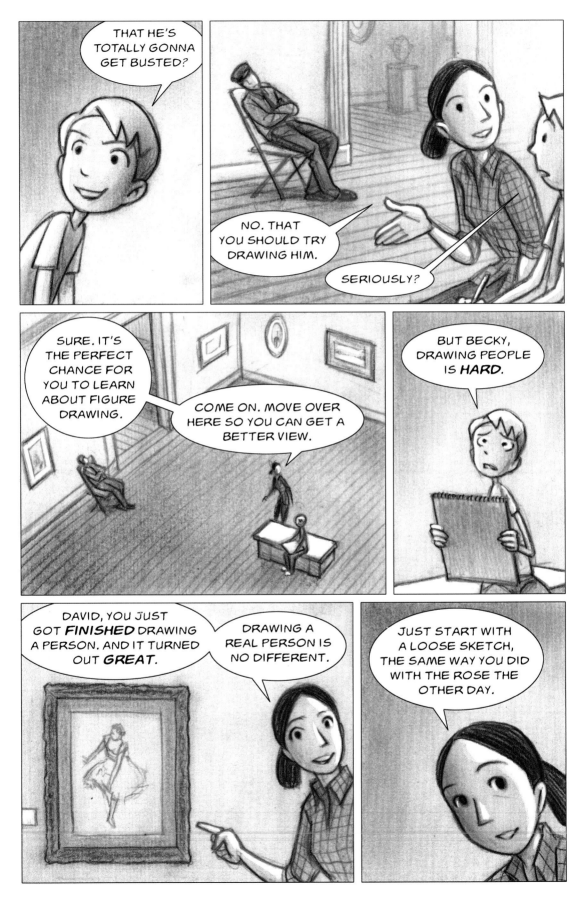

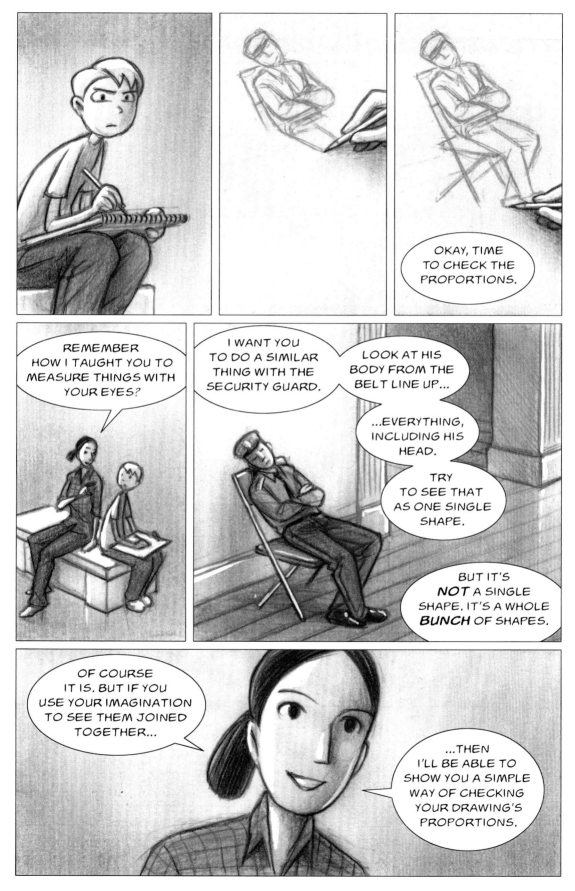

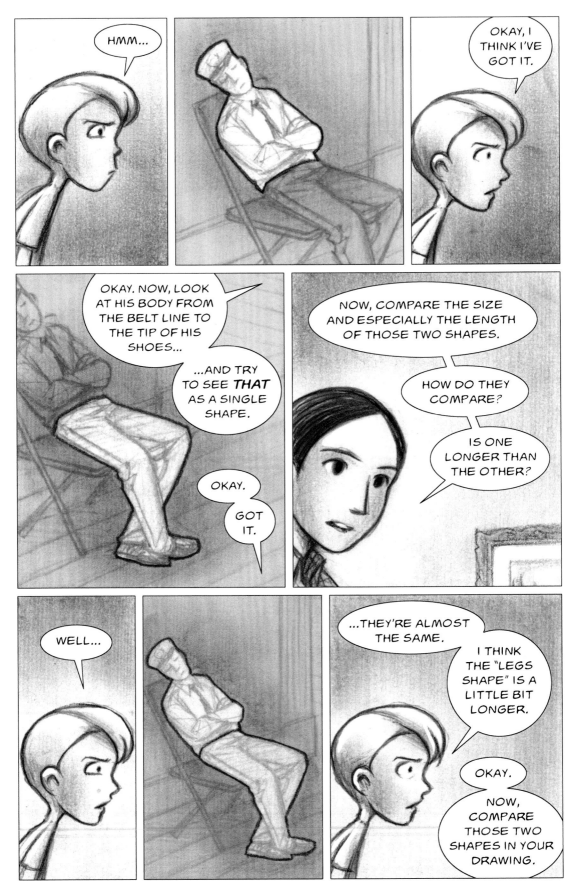

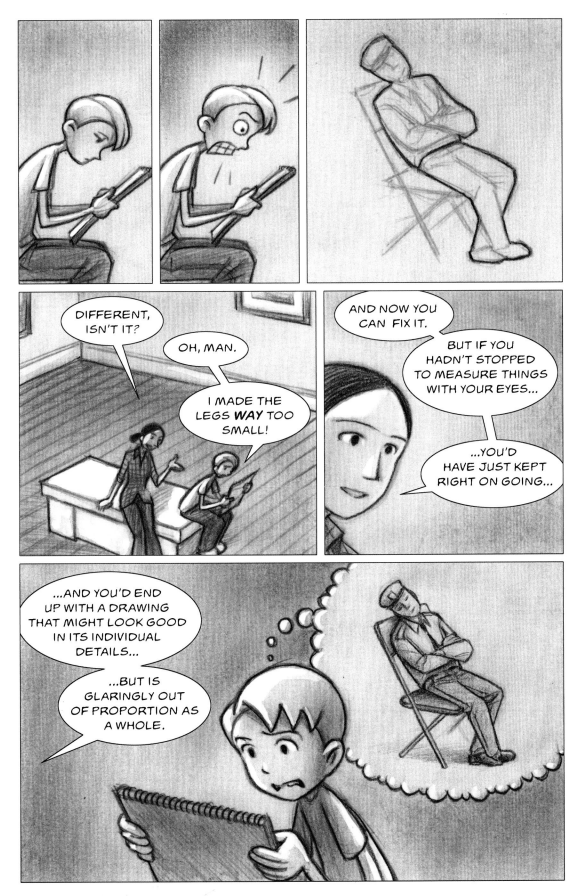

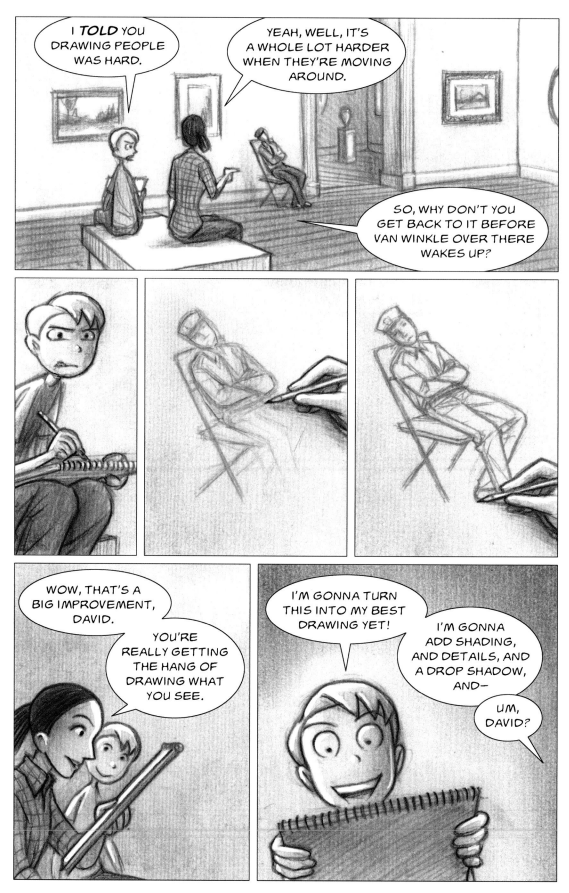

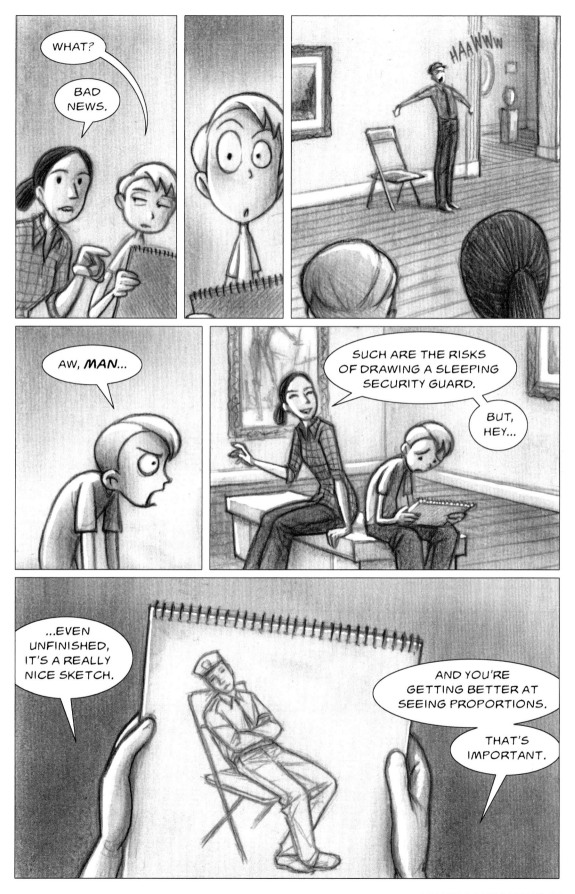

Try doing a loose, sketchy figure drawing, either from life or from a photo. Use the tricks Becky taught to help you check and correct proportions in your drawing before finalizing any of the lines.

SIMPLIFYING THINGS

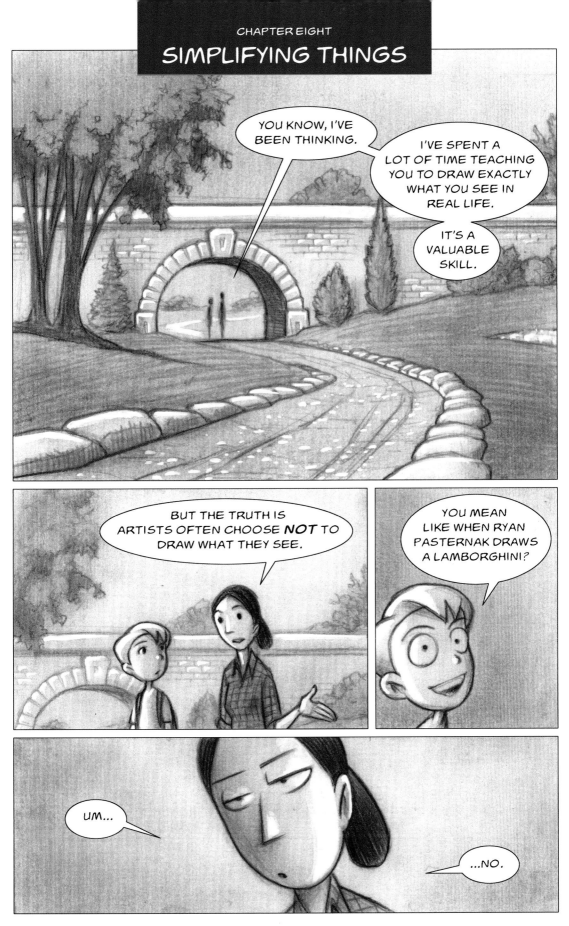

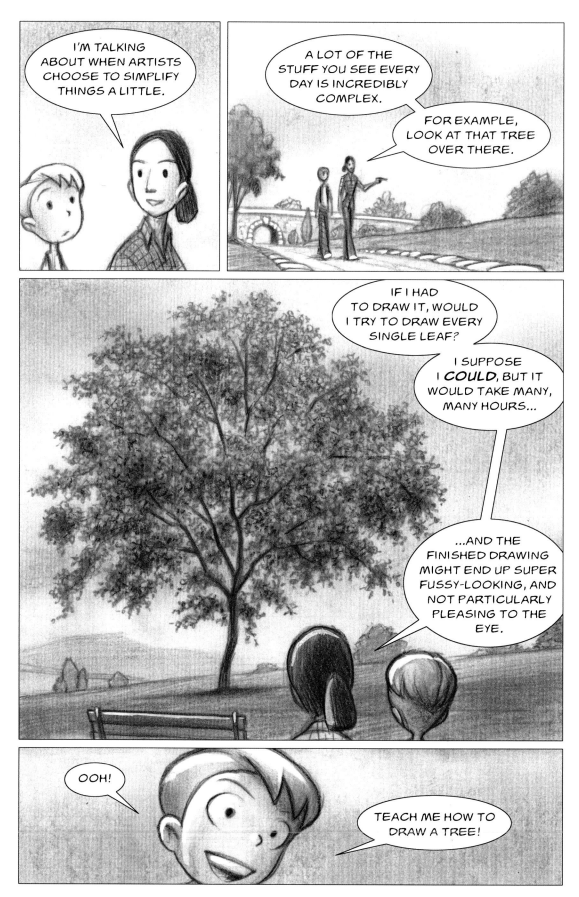

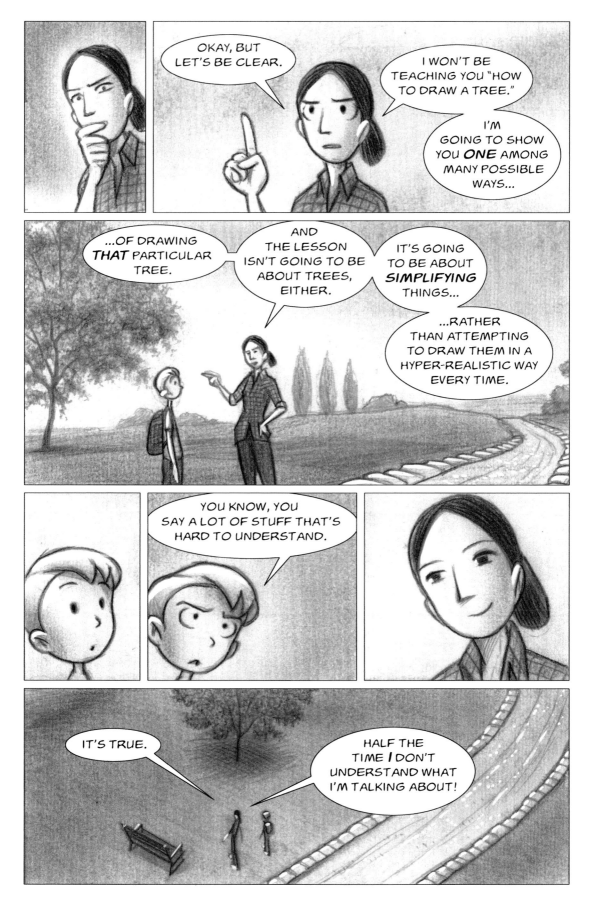

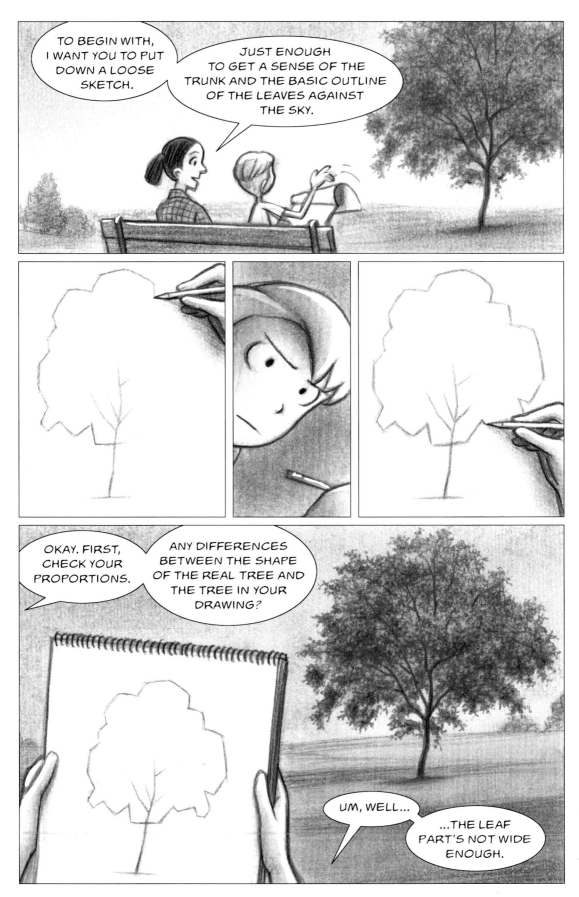

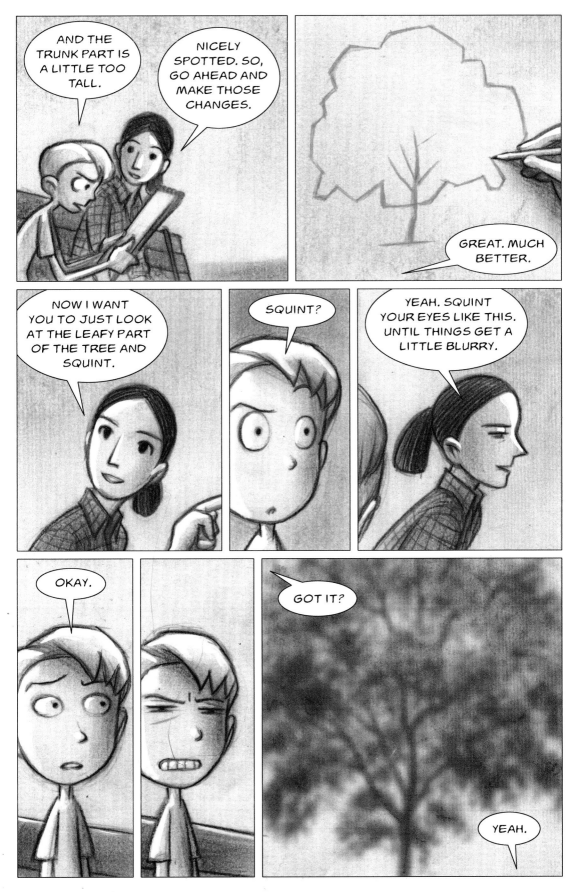

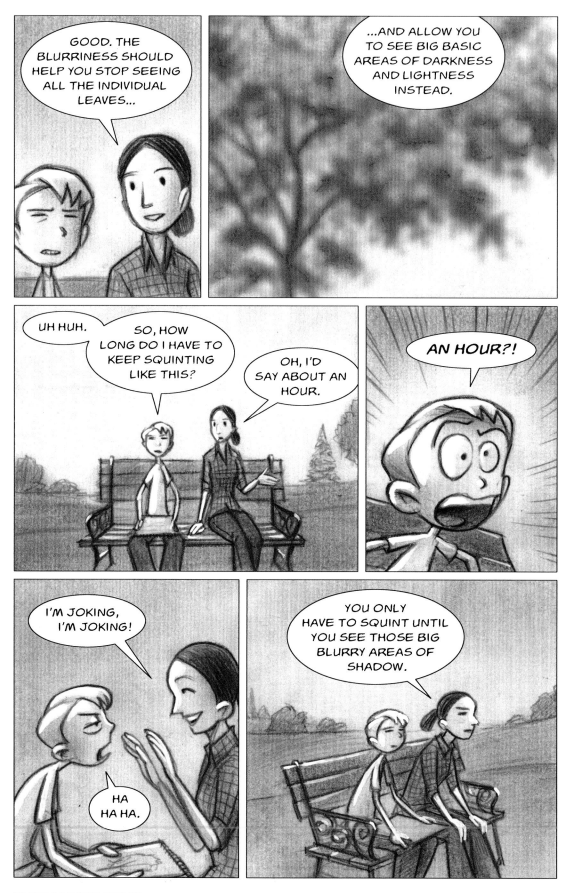

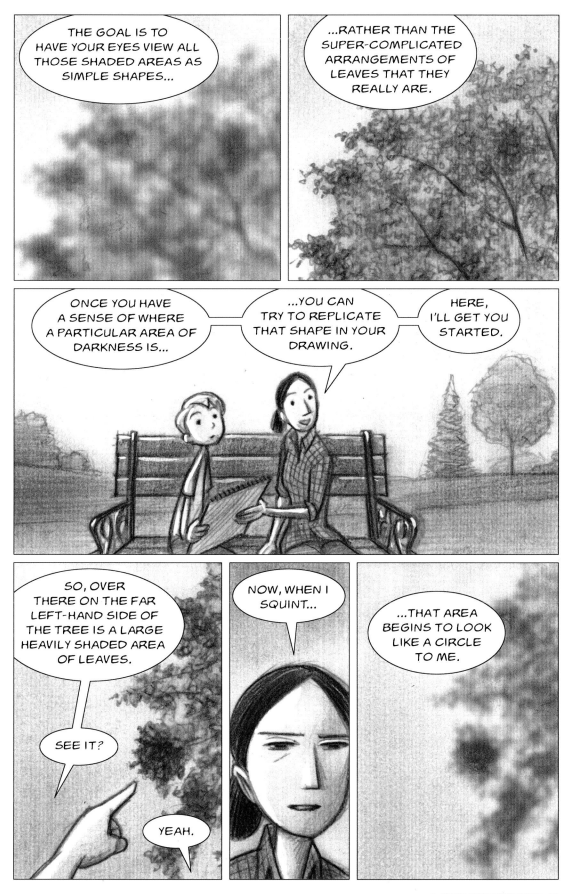

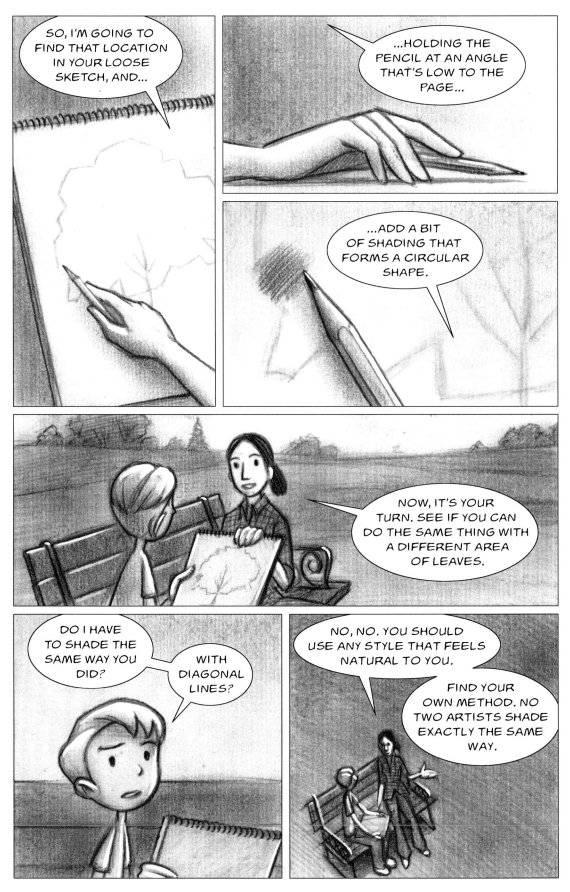

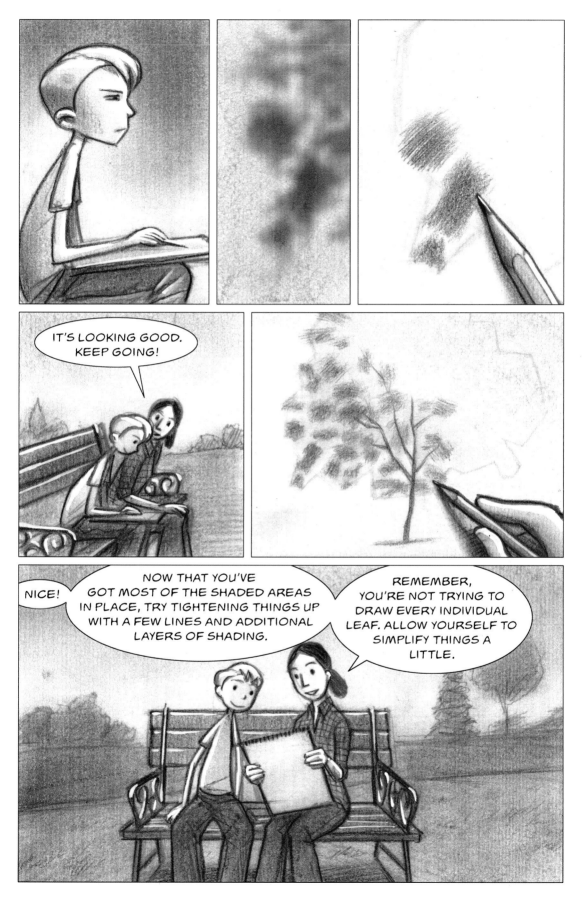

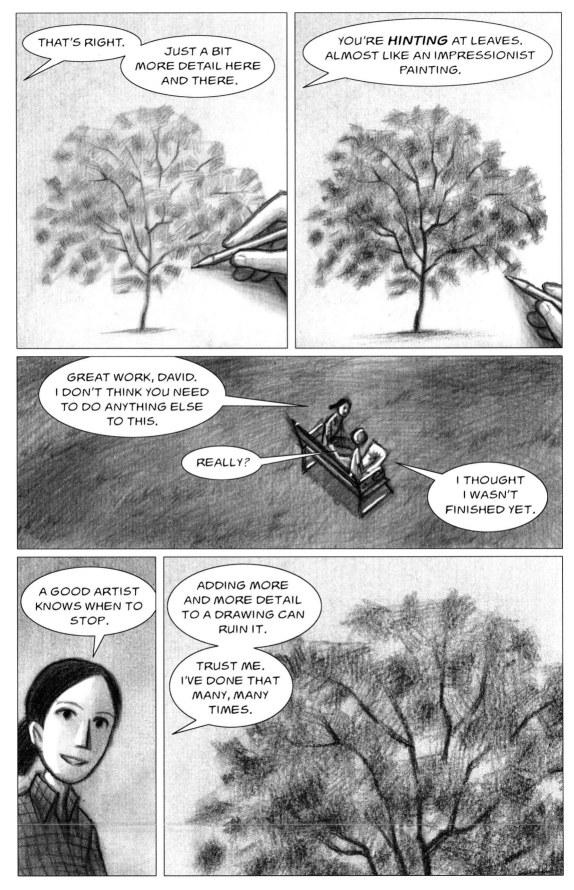

Take on the challenge of a highly detailed subject, squinting your eyes to see its bold basic shapes. Feel free to keep it loose and impressionistic, and to not concern yourself with every single detail.

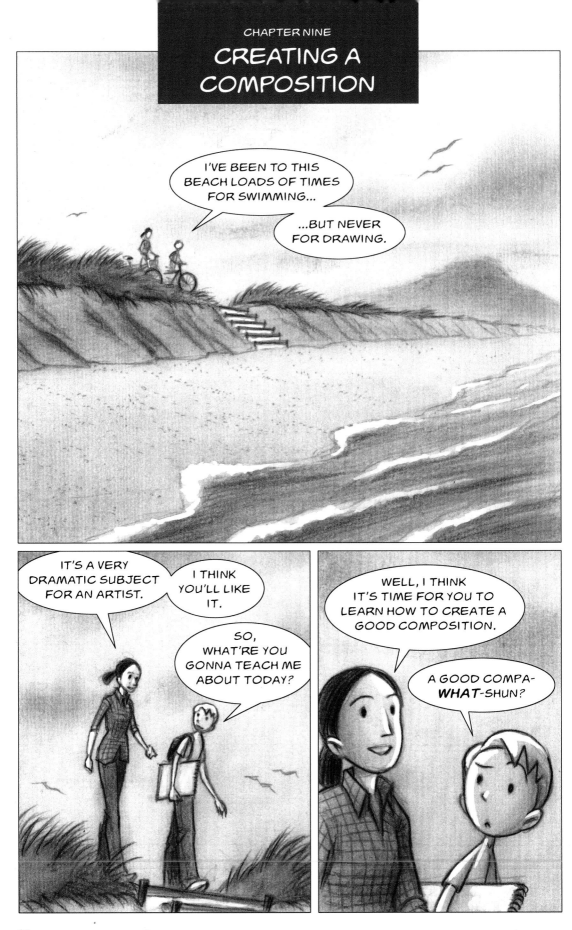

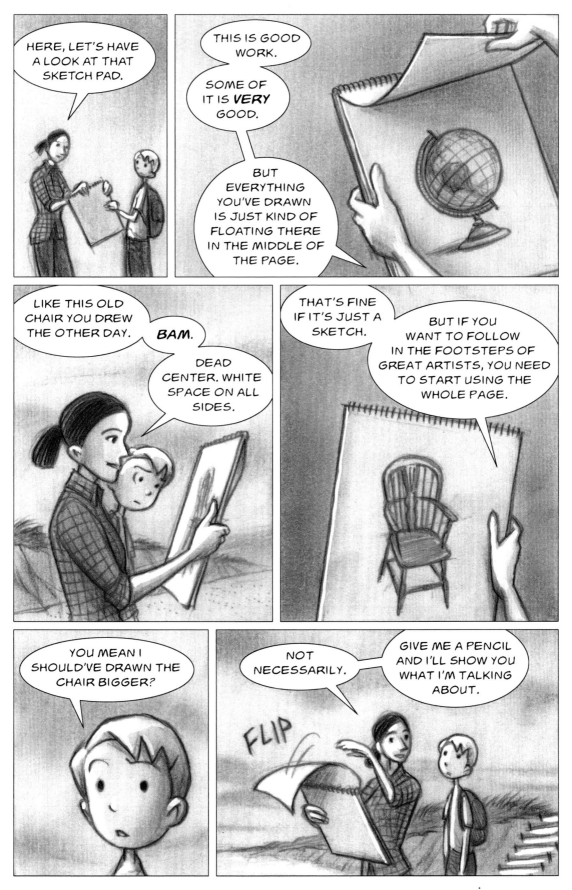

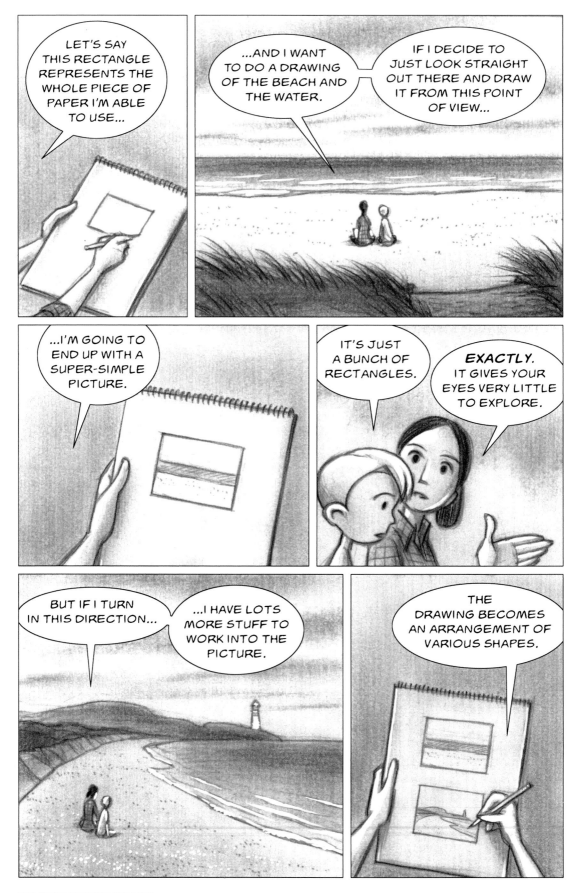

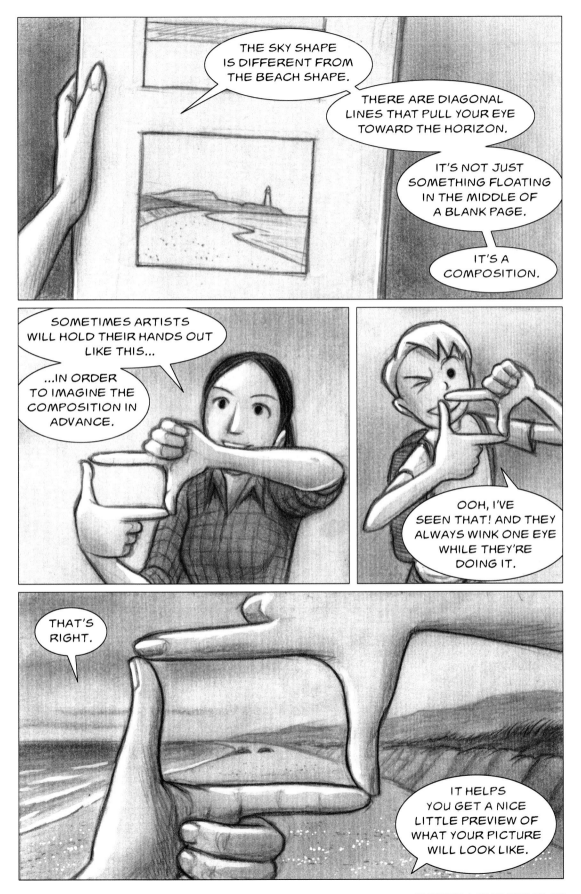

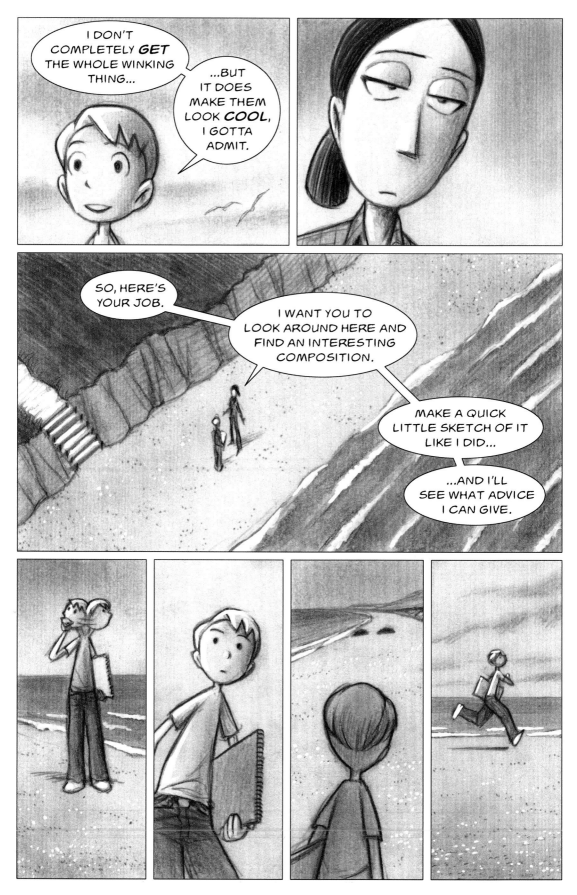

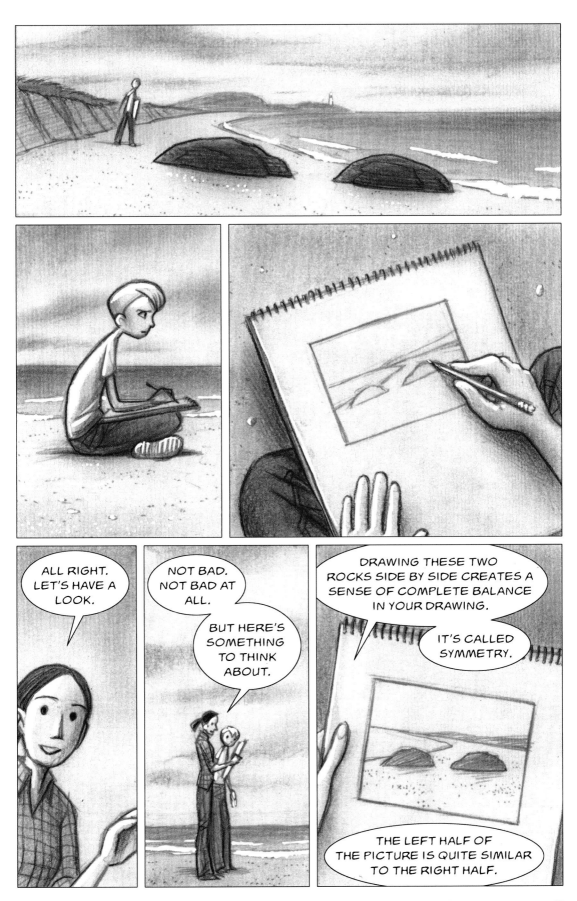

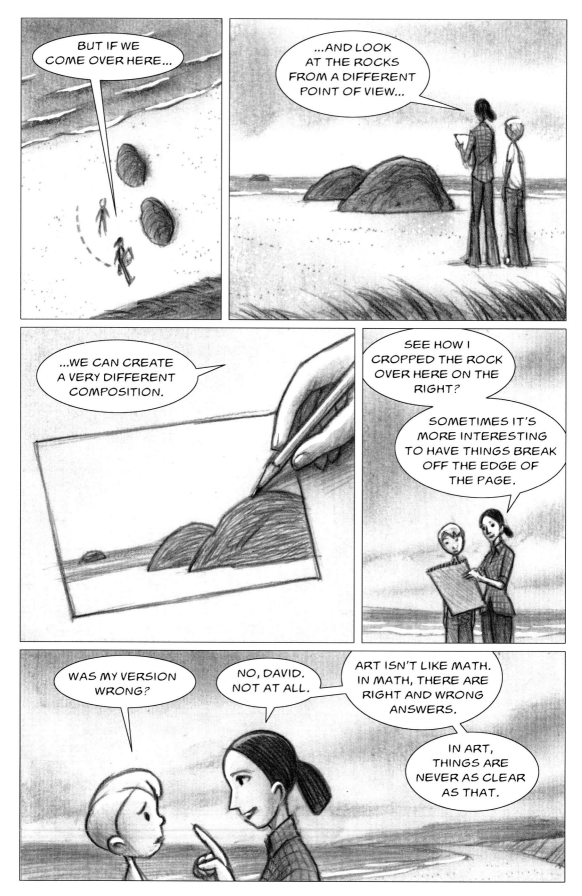

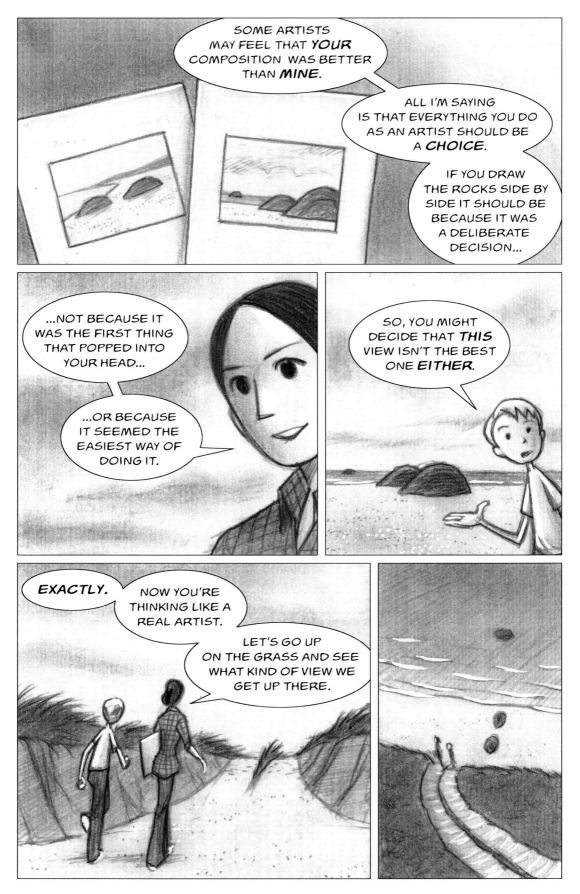

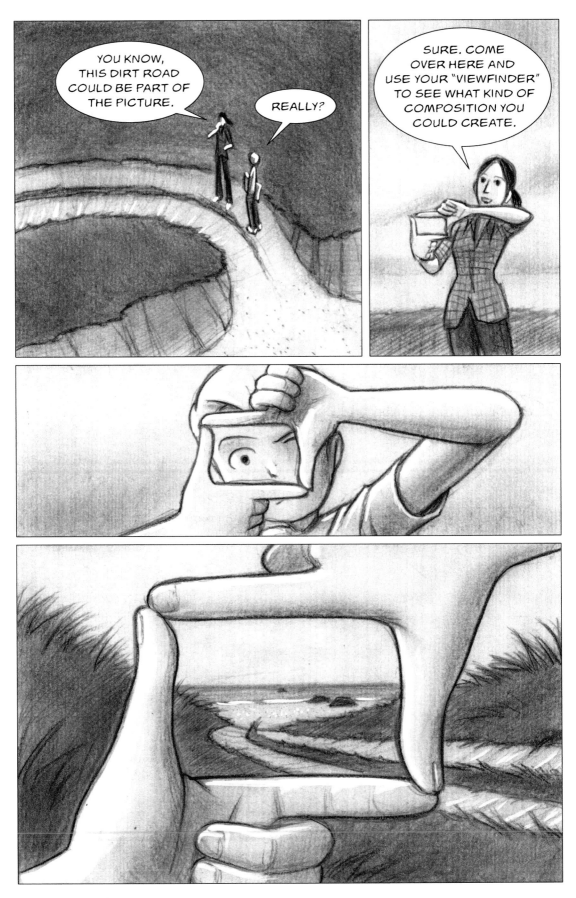

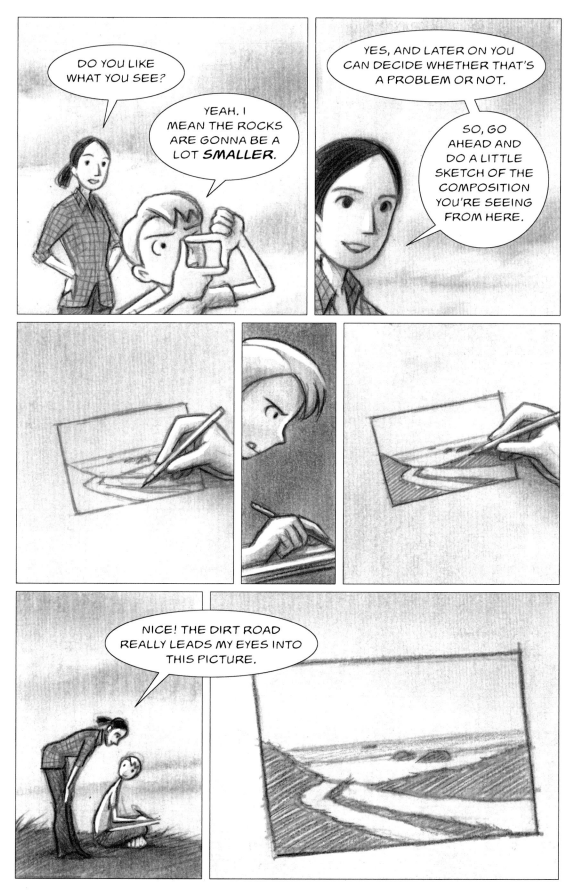

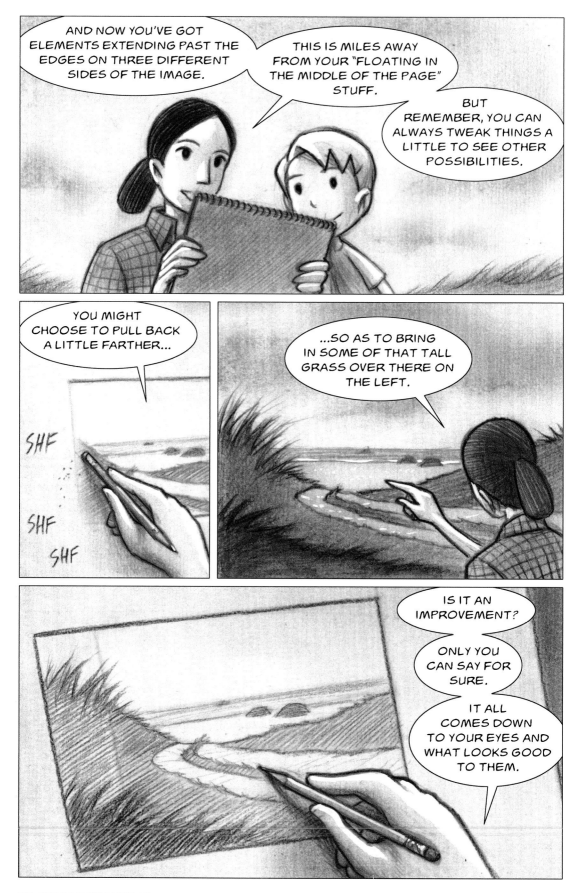

Go to a favorite location and scout the area for a good composition. Avoid placing a single big object in the very center of the page, and consider having some elements extend past the edges of the paper.

BRINGING IT ALL TOGETHER

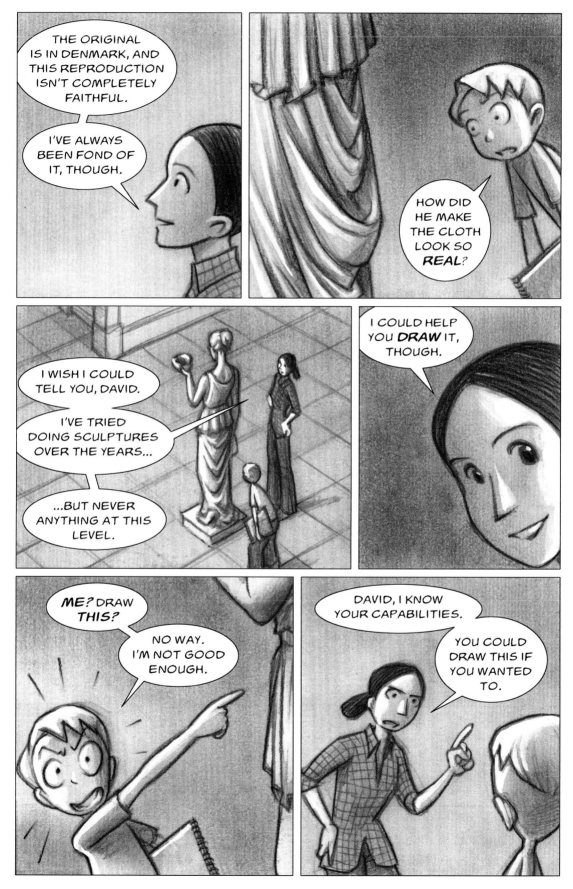

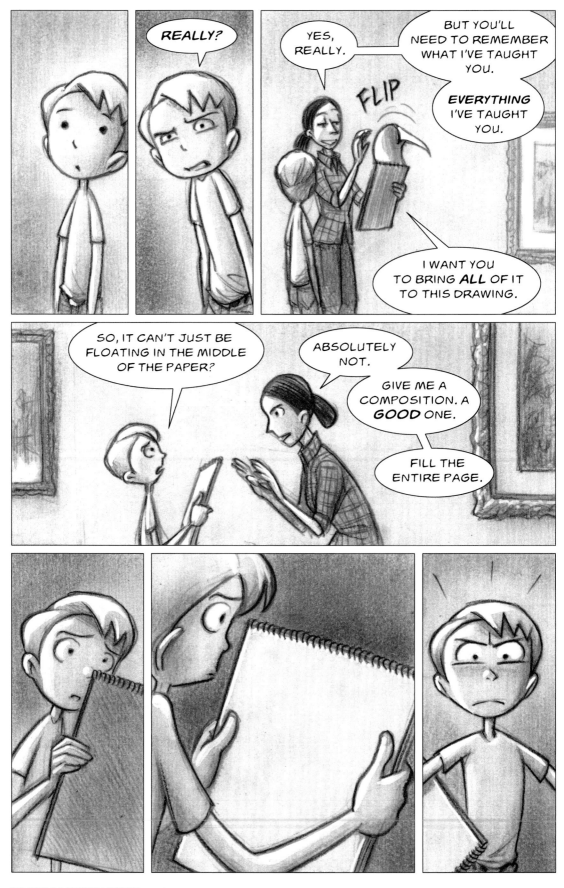

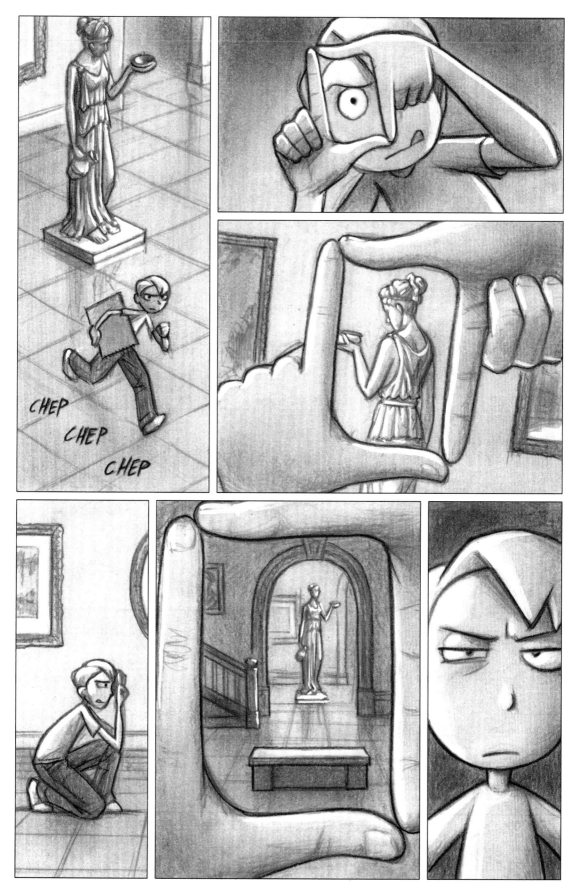

CHEP

CHEP

CHEP

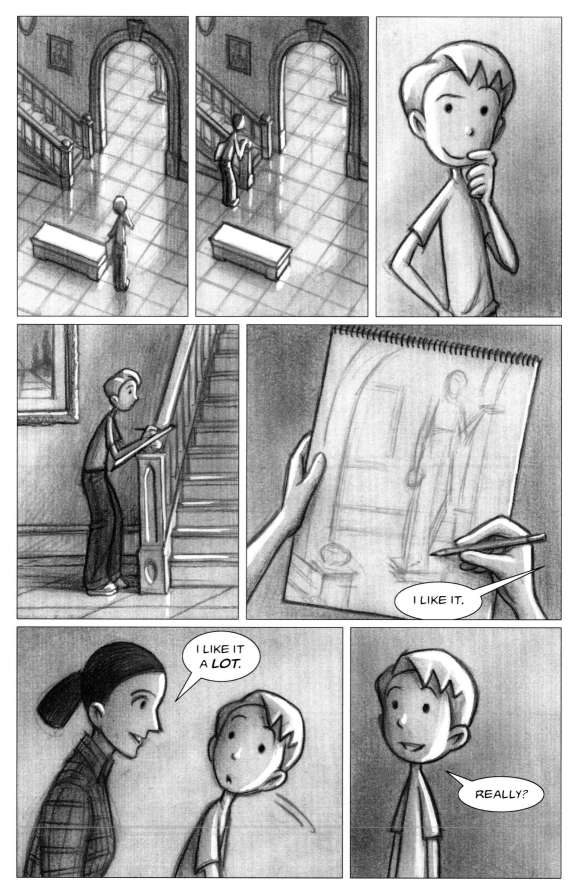

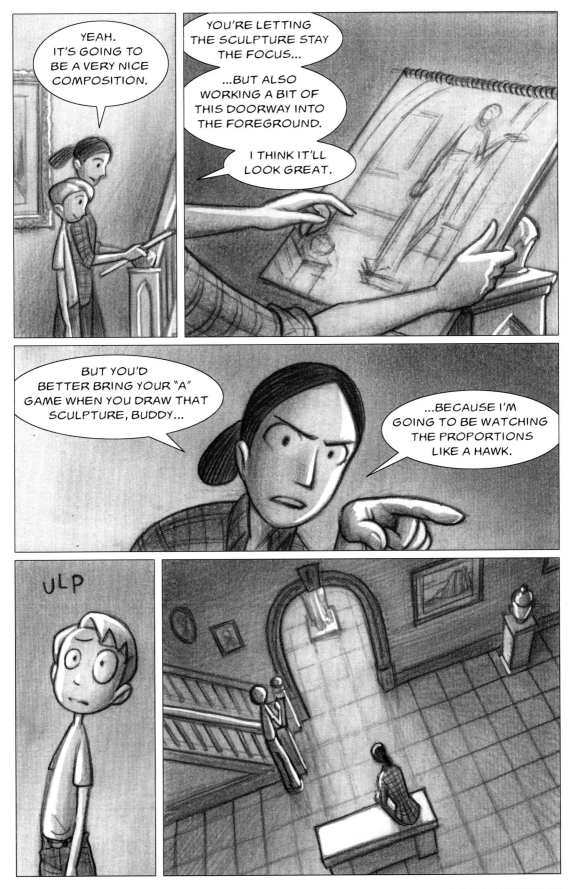

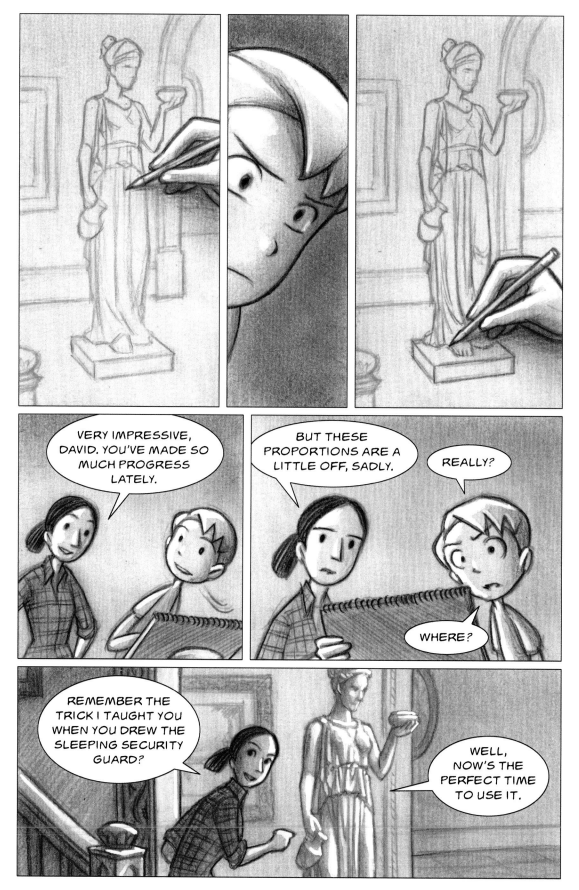

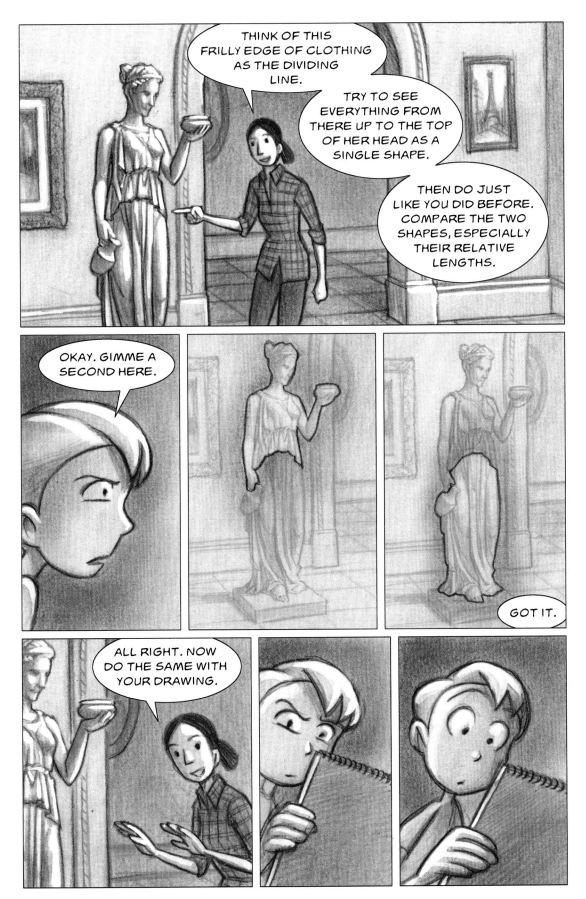

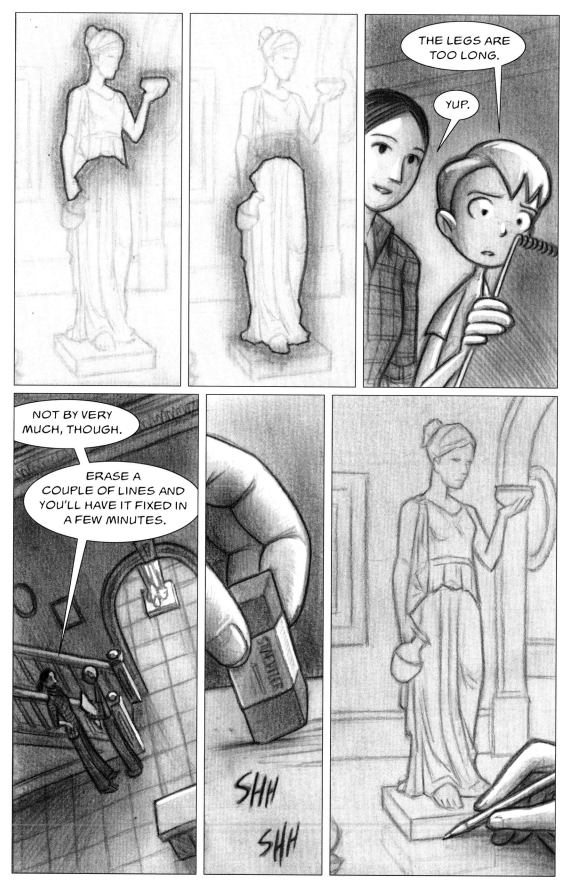

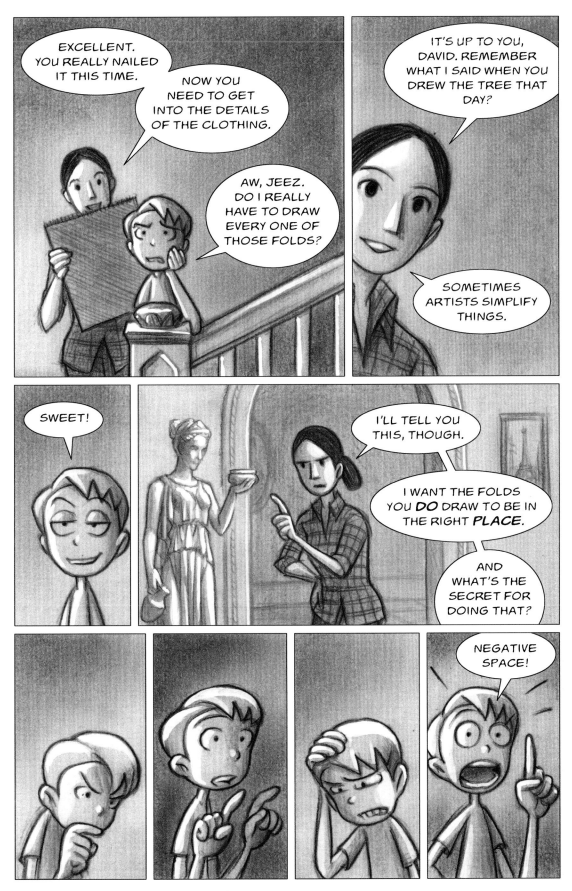

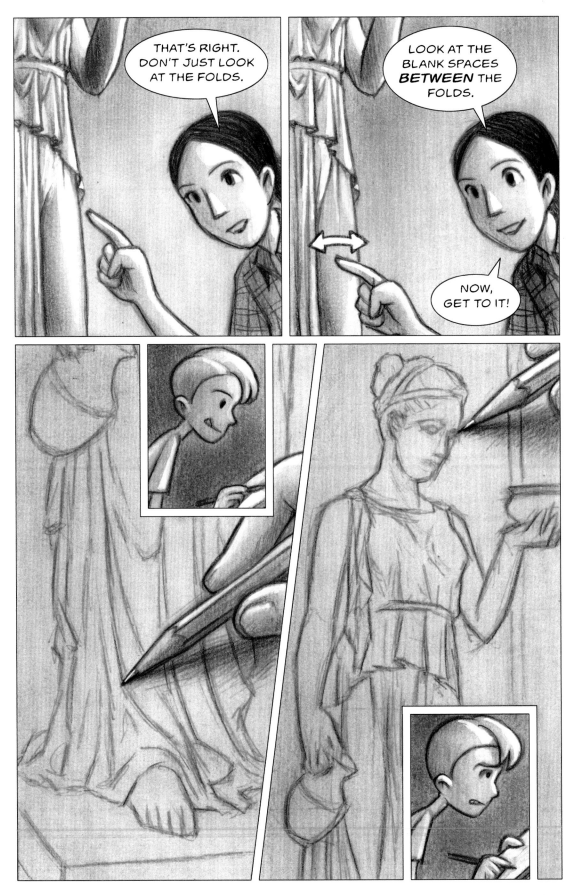

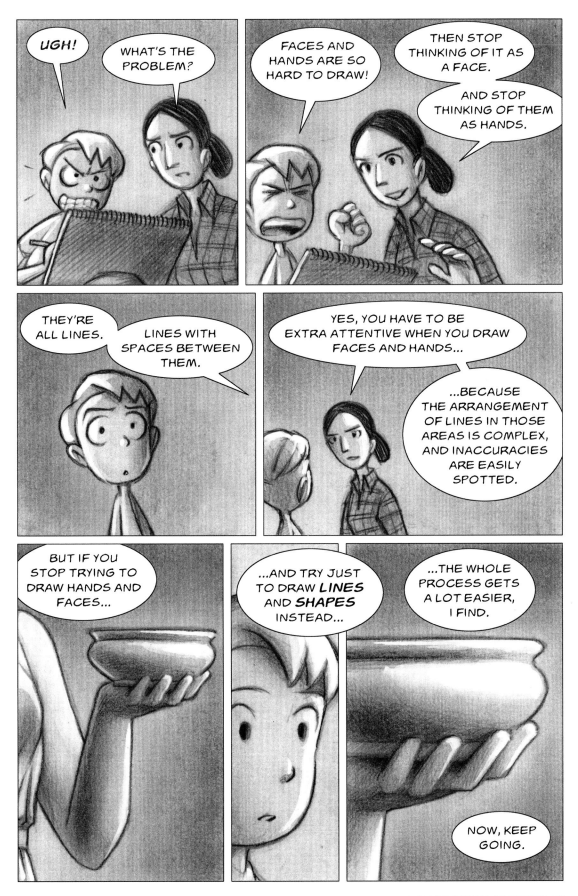

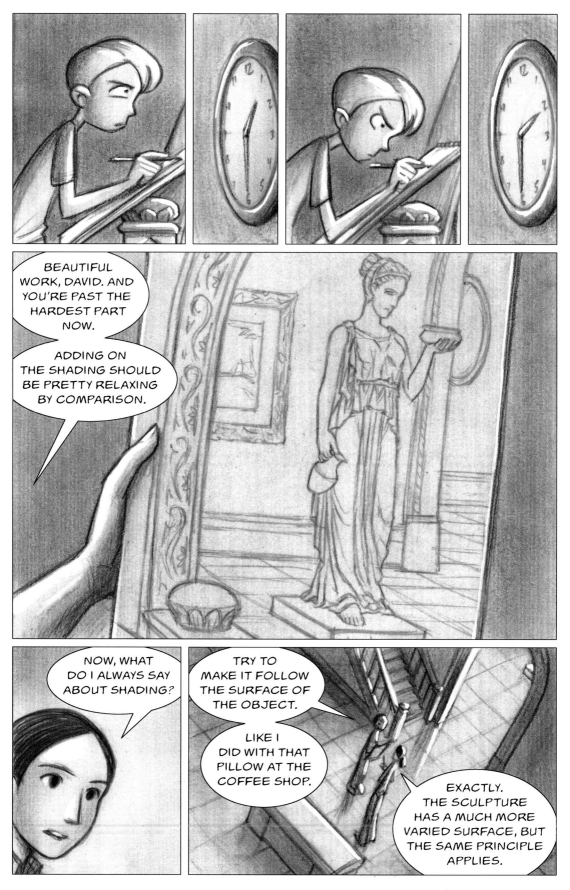

BEAUTIFUL WORK, DAVID. AND YOU'RE PAST THE HARDEST PART NOW.

ADDING ON THE SHADING SHOULD BE PRETTY RELAXING BY COMPARISON.

NOW, WHAT DO I ALWAYS SAY ABOUT SHADING?

TRY TO MAKE IT FOLLOW THE SURFACE OF THE OBJECT.

LIKE I DID WITH THAT PILLOW AT THE COFFEE SHOP.

EXACTLY. THE SCULPTURE HAS A MUCH MORE VARIED SURFACE, BUT THE SAME PRINCIPLE APPLIES.

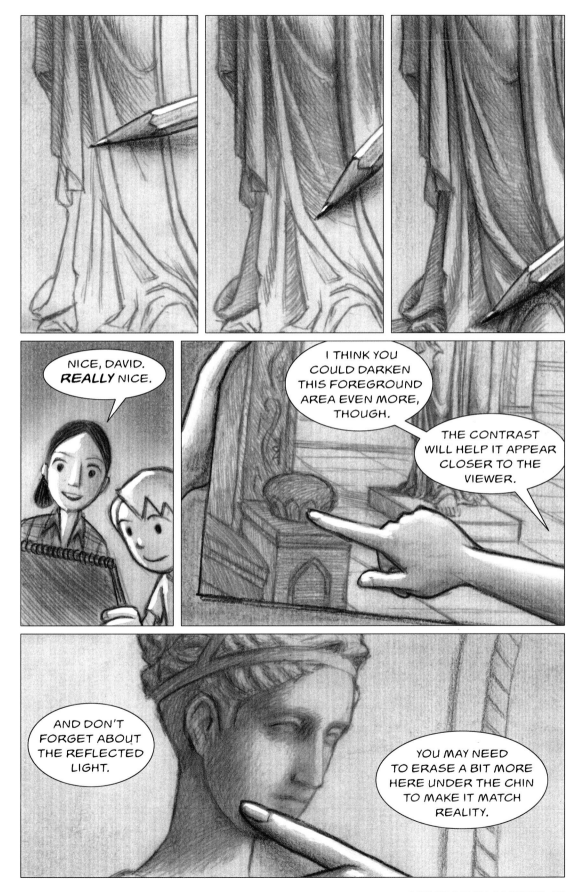

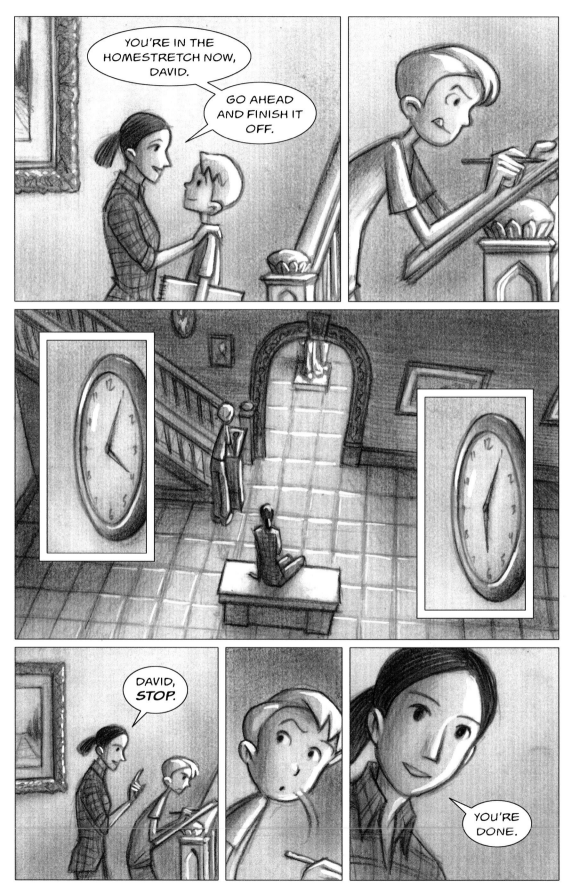

Challenge yourself to do a big ambitious drawing that requires full use of all the skills you've practiced throughout this book. Remember to check your proportions so that everything is where you want it to be before you add details and shading.

CHAPTER ELEVEN
MOVING ON

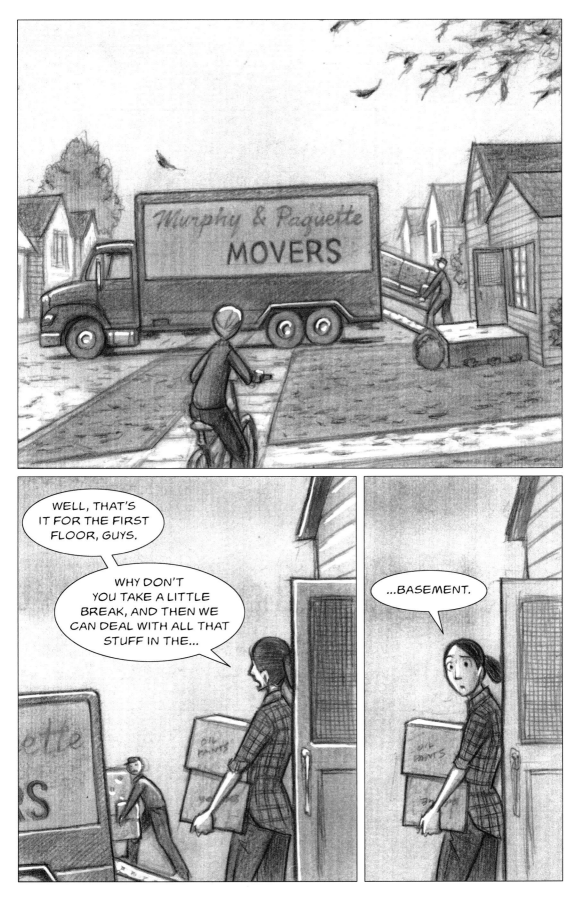

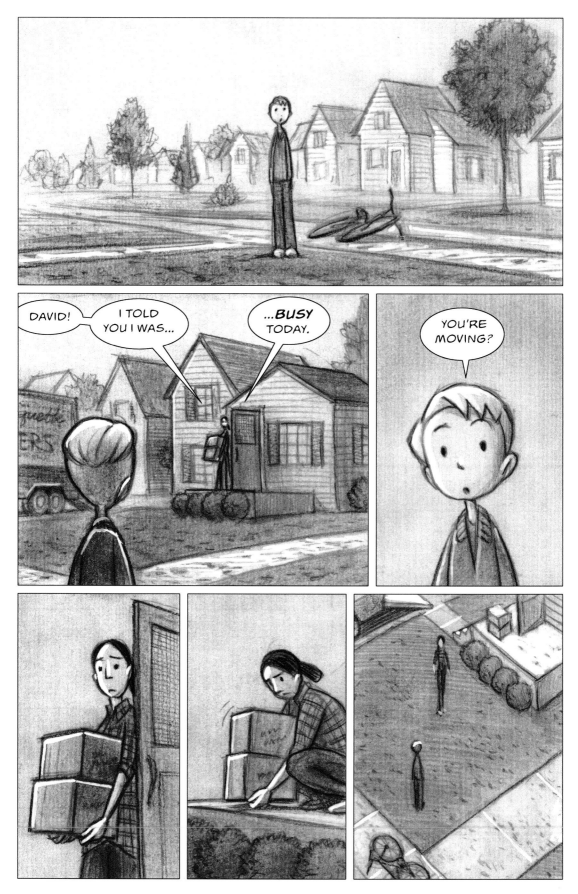

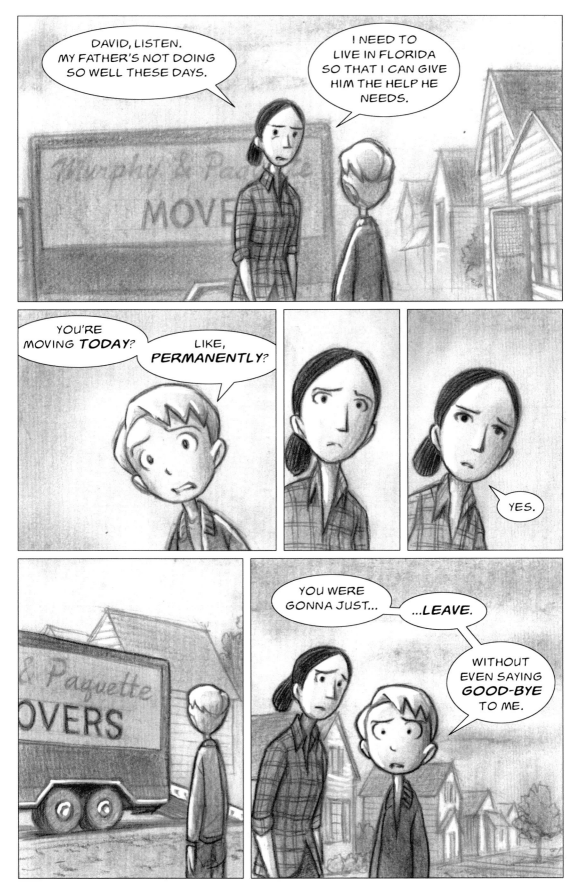

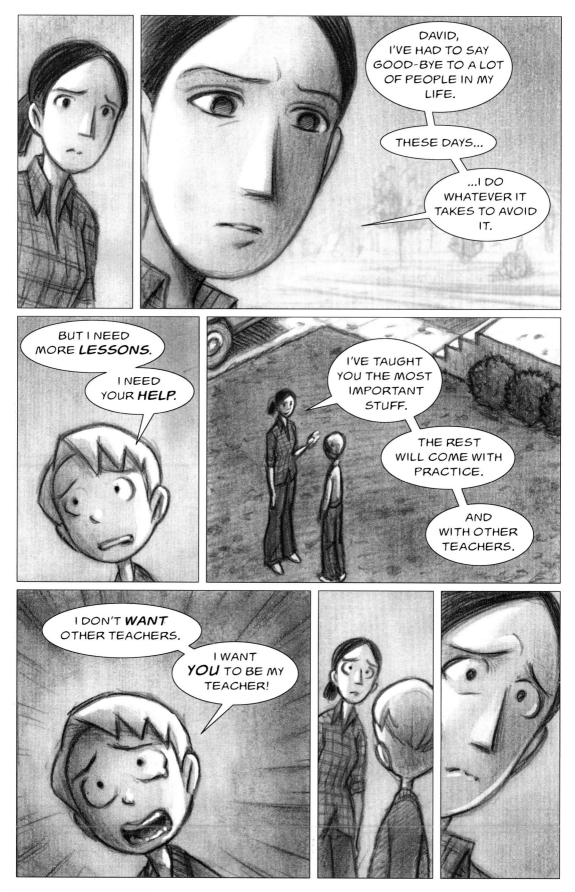

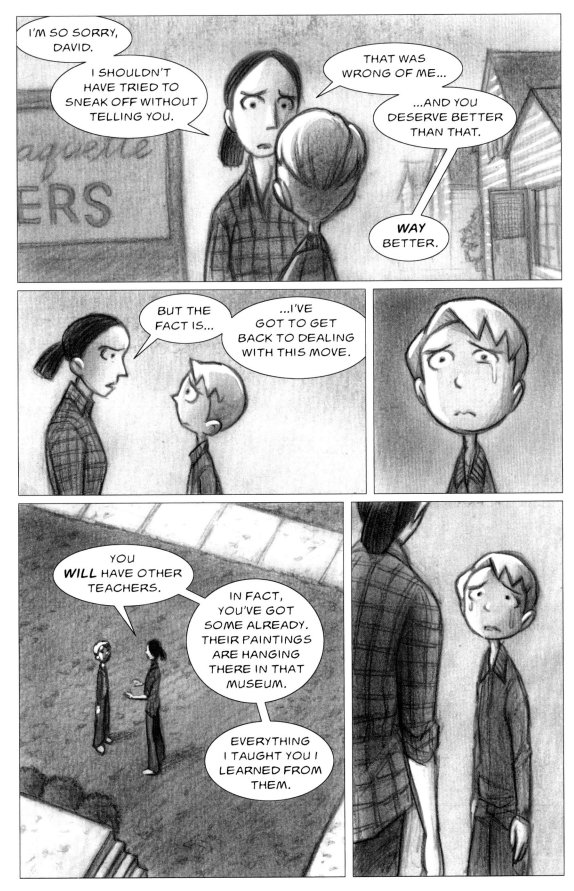

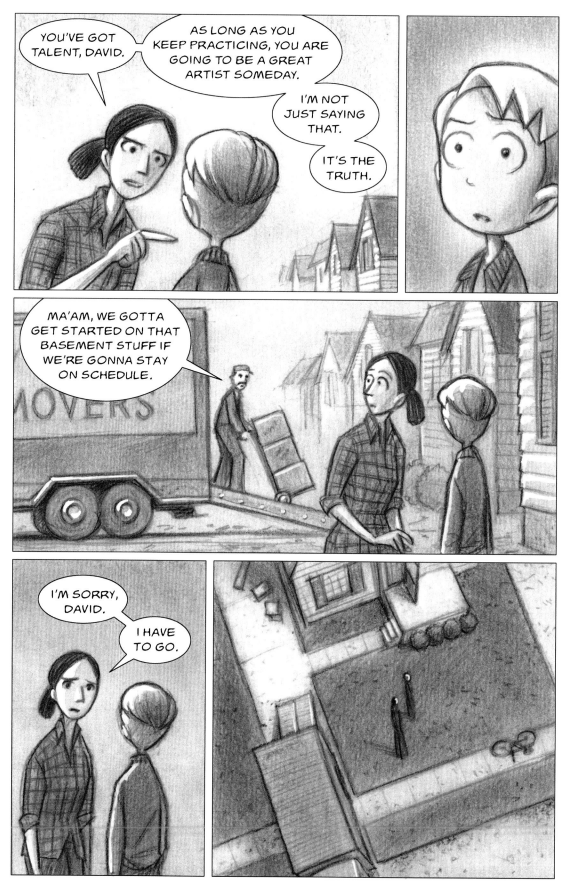

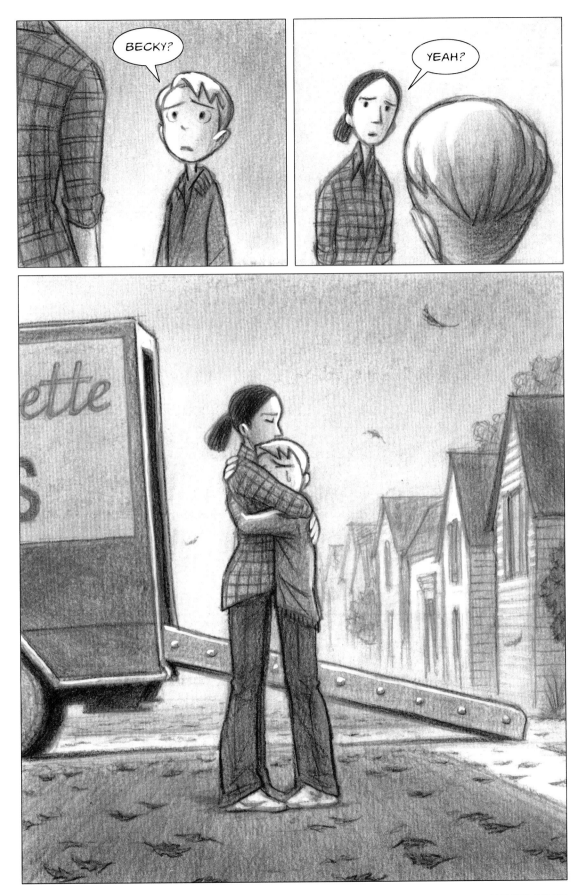

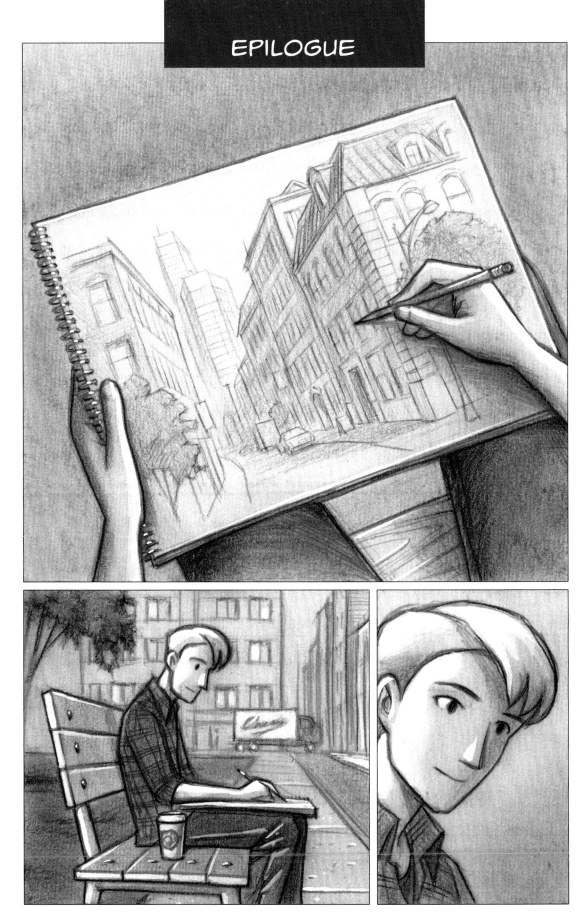

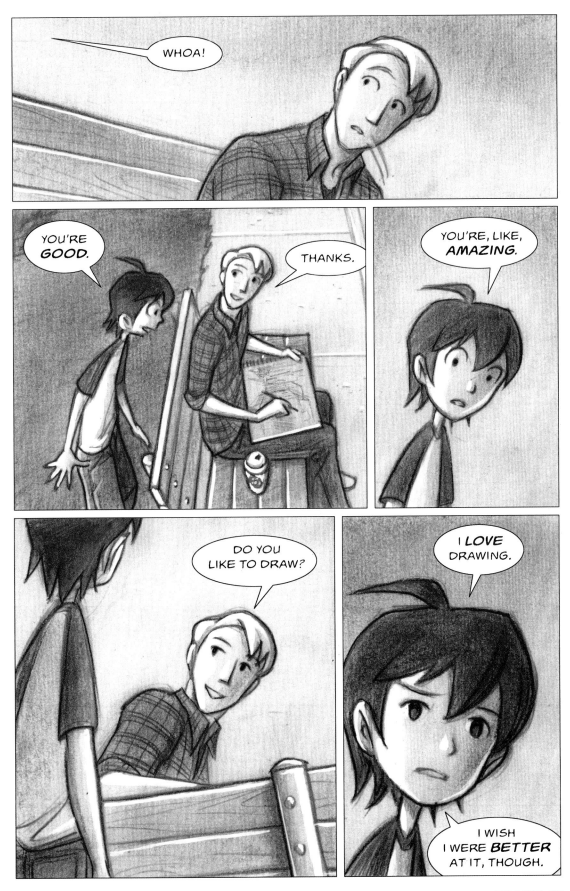

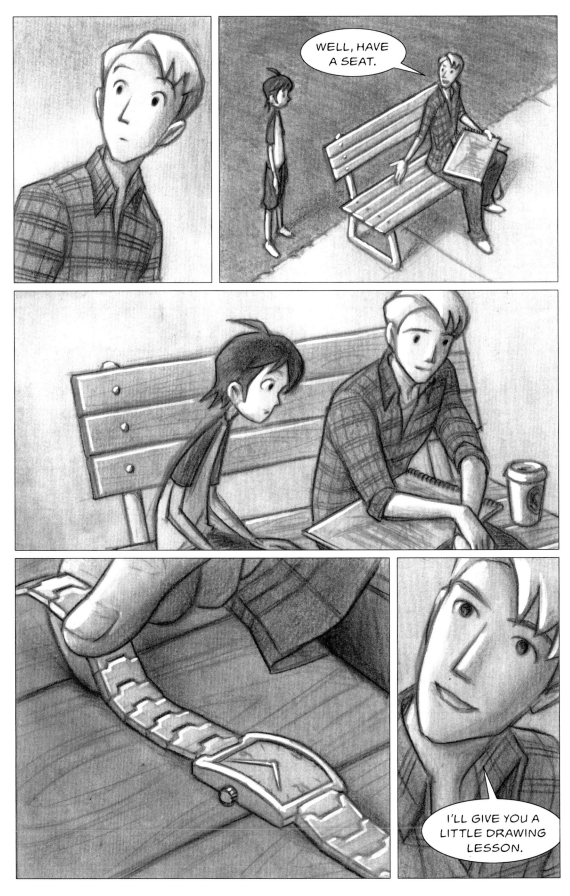

THE END

THIS BOOK IS DEDICATED TO DAVID SMALL,
MY REAL-LIFE DRAWING MENTOR

Copyright © 2016 by Mark Crilley

Published in the United States by Watson-Guptill Publications, an imprint
of the Crown Publishing Group, a division of Penguin Random House LLC,
New York.
www.crownpublishing.com
www.watsonguptill.com

WATSON-GUPTILL and the WG and Horse designs are registered
trademarks of Penguin Random House LLC

Library of Congress Cataloging-in-Publication Data
Crilley, Mark, author.
The drawing mentor : an illustrated story that teaches you how to draw /
Mark Crilley. — First Edition.
pages cm
Includes bibliographical references and index.
1. Drawing—Technique—Comic books, strips, etc. I. Title.
NC730.C685 2016
741.2—dc23
2015028028

Trade Paperback ISBN: 978-0-3853-4633-7
eBook ISBN: 978-0-3853-4634-4

Printed in China

Design by Ashley Lima

10 9 8 7

First Edition